DETROIT ACES

THE FIRST 75 YEARS

Our mascot. Despite the fact that no tiger was ever native to Michigan, the striped cat has been our favorite animal.

DETROIT ACES

THE FIRST 75 YEARS

Mark Rucker

ARCADIA

Published by Arcadia Publishing
Charleston SC, Chicago IL, Portsmouth NH, San Francisco CA

Printed in Great Britain

Library of Congress Catalog Card Number: 2005933669

For all general information contact Arcadia Publishing at:
Telephone 843-853-2070
Fax 843-853-0044
E-mail sales@arcadiapublishing.com
For customer service and orders:
Toll-Free 1-888-313-2665

Visit us on the internet at http://www.arcadiapublishing.com

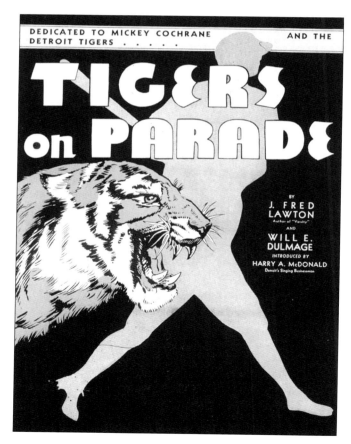

This piece of sheet music was issued in 1934, as the Tigers became a force in the American League in the mid-1930s.

CONTENTS

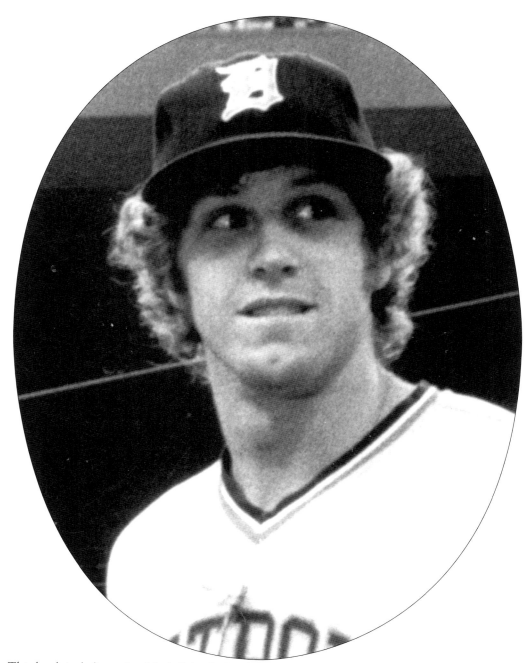

This book is dedicated to Mark Fidrych. He did not play during the era this book covers, but he does represent to Detroit, and to the world, the spirit of joy in competition and the love of our great game. He did not last long in the majors, but his presence was a thrill for the Motor City and all who got to see him.

INTRODUCTION

Detroit baseball fans could be called tenacious, or long-suffering, or even foolish sometimes, but one thing we definitely are is loyal. We watched some topflight ball games during the first years of the National League franchise, and then during the Western League years, lasting from 1889 to 1901. Before 1881, we saw some pretty ragged ball play around the city, but the teams were almost all amateurs, and sometimes the players looked like they were right off the farm. The fields they played on some days provided a circus of bad-hop ground balls that eliminated the opportunity to play skillfully. But we stuck with our favorite sport, and in 1881, our loyalty paid off, as Detroit entered the spring with its first major-league team. Detroiters really packed the park that season, to see topflight baseball and ballplayers from all over the country. They were our team, and we loved them. Detroiters were delighted to find that a future National Baseball Hall of Fame member would be in the club when Ned Hanlon came over from Worcester. We knew the team would inevitably get better, just like the city. Detroit was not a metropolis, but it had an 1880 population in the city proper of over 116,000, with all activity starting at the river and working inland from there. We were true fanatics of the national pastime, and we would put Detroit on the baseball map for good.

As the 1880s rolled by, the city kept growing and the ball club kept improving. The first manager, Frank Bancroft, gave way to John Chapman in 1883, who then handed over the reins to Henry Watkins in 1885. In 1887, we won the pennant with a fabulous starting lineup including Charlie Getzein, Larry Twitchell, and Lady Baldwin on the mound. But with financial problems mounting, and fan attendance falling in 1888, at the end of the season the team fled town. Some fans paid particular attention to the parade of pitchers onto and off of the Detroit roster in those early years. Two Georges were the early workhorses and stars, George Derby, who won 29 games in 1881 and 16 in 1882, and George "Stump" Weidman, who stayed in Detroit for six years, won 34 games over the team's first two campaigns. By 1884, none of Detroit's seven pitchers could win more than nine games. And three years later when we won the title, it was hitting, not pitching, that got us over, as there was but one 20-game winner, Charlie Getzein with 29, while Philadelphia, who finished four games behind, had three pitchers with 20. But any smug feelings soon disappeared, as virtually the same team struggled to a fifth-place finish the next year, with results so frustrating that no one had any idea what went wrong. The team changed hands, and before anyone knew it, the club was broken up, and the stars were shipped off to Boston, Cleveland, and Pittsburgh.

After that, southern Michigan was in the baseball dumps with little professional action around. Finally, in 1894, Ban Johnson launched the Western League, and Detroit had a real team once

more. By 1895, George Stallings was hired as manager, and things became much more lively. He was let go in 1896, but was back again in 1899, bringing the "Tabasco Kid" Elberfield with him. He was the managerial continuity from minor- to major-league baseball, as the Western League was reborn as the new American League in 1901. We were particularly excited because the team had been successful in its league before, and almost all Western League opponents were now major-league teams. In addition, the city had grown to 286,000 people, and baseball was still growing in popularity along the Detroit River.

In 1901, we fielded a team of players no one would ever have heard of. Elberfield is probably the most recognizable; the "Tabasco Kid" hit .308 as the Tigers finished in third place, 13 games over .500. We played well and drew good crowds to the ballpark, built on the old hay market. We called it Bennett Park after the star catcher and civic activist Charlie Bennett, who lost his legs in a railroad accident. The park was located at the corner of Michigan Avenue and Trumbull. And fans always loaded up on food and drink along Michigan before they got there. Then Frank Dwyer took over in 1902, and the team sunk to seventh place. Ed Barrow did little better in 1903. We could not get any traction as a franchise until Tyrus Raymond Cobb showed up in 1907. His ferocity and staggering talent lifted the club to another level. Cobb brought out a competitiveness that the Tigers were missing. Cobb led the league in hitting with .350 as a rookie while he led the Tigers to the pennant in 1907, 1908, and then again in 1909. We had great pitching, which secured the championship in 1907, with three 20-game winners: George Mullin with 20, Ed Killian with 25, and "Wild Bill" Donovan with 25. When we won again a year later, only Ed Summers topped the 20 mark with 24, and in 1909, Mullin won 29 and Ed Willet racked up 21. It was the most reliable staff Detroit had ever seen and was the envy of the American League. After 1909, the Philadelphia Athletics put together a great team and knocked Detroit out of first in 1910, 1911, 1913, 1914, and 1915. It was the Boston Red Sox who won the flag in 1912, as Detroit struggled with an aging pitching staff, and against steadily improving competition in the American League. The old-timers say that these were the best baseball years the city ever saw.

ONE

The Wolverines Morph into Tigers

1881–1915

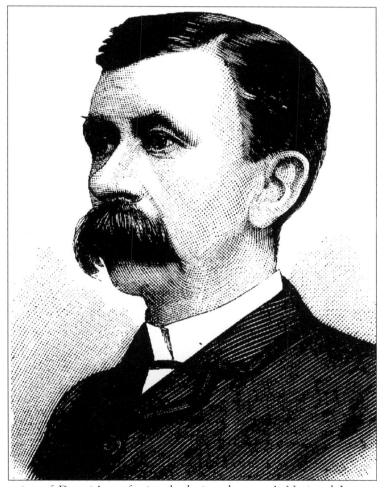

Frank Bancroft took the reins of Detroit's professionals during the team's National League incarnation in 1881. He took the club to a 41-42 fourth-place finish that year and then to a worse finish but better record, 42-41, in 1882. In 1883, he was gone.

Dupee Shaw

Dupee Shaw, whose real name was Frederick Lander, was supposed to be the star pitcher in 1883, or at least the Detroit fans thought so. In that first season with Chapman as manager, he compiled a 10-15 record, which was below expectations. It turned out to be Stump Weidman who was the hero, winning 20 games, while losing 24. Shaw would later find success in the Union Association, where the competition was not as rough.

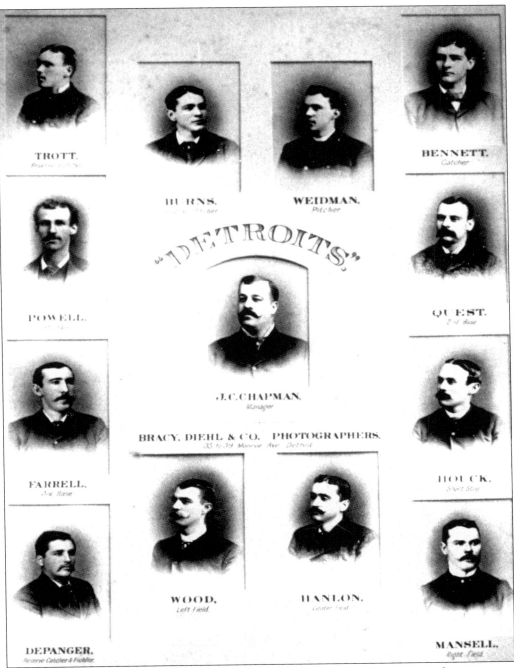

TROTT.
Reserve Catcher

BURNS.
Pitcher

WEIDMAN.
Pitcher

BENNETT.
Catcher

"DETROITS"

POWELL.

QUEST.
2nd Base

J. C. CHAPMAN.
Manager

BRACY, DIEHL & CO. PHOTOGRAPHERS.
35 to 39 Monroe Ave. Detroit

FARRELL.
3rd Base

HOUCK.
Short Stop

DEPANGER.
Reserve Catcher & Fielder.

WOOD.
Left Field

HANLON.
Center Field

MANSELL.
Right Field

Yes, 1883 was a year we thought Detroit could put together a run at the pennant, but it was not in the arms. Weidman won 20, but Shaw with 10, Dick Burns with a 2-12 record, and Jumping Jack Jones with 6-5, we were not going to make it. The collage above depicts some of the hurlers in 1883, with Weidman and Burns at top, center. It was a good-looking group, with Ned Hanlon in center field and Charlie Bennett behind the plate to educate the struggling pitchers.

George Wood
Career 1880–1892 Detroit 1881–1885

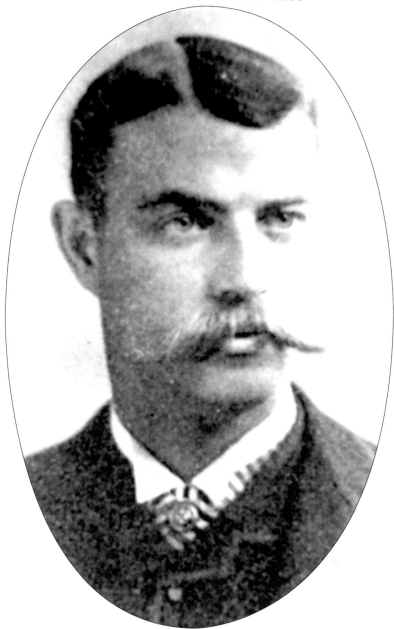

George Wood was an outfielder by trade, but in a desperate pinch, he would be used as a relief pitcher. He threw one inning in 1883 and one inning in 1885, and the fans cringed when he approached the mound. In 1883, he pitched five total innings and racked up a 7.20 earned-run average, but in 1885, he threw four innings and gave up nothing.

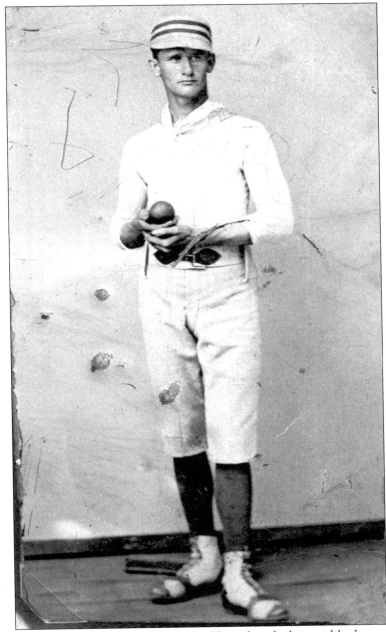

Pete Conway came to Detroit from Kansas City, where he had been knocked around by league hitters. He found a home in Detroit for a few years, and by 1888 was the best pitcher on the team. He finished 8-9 after the pennant drive of 1887, but his 30-win mark in 1888 was third best in the National League and the best the Wolverines had seen. This beat-up tintype is the best image we have of him.

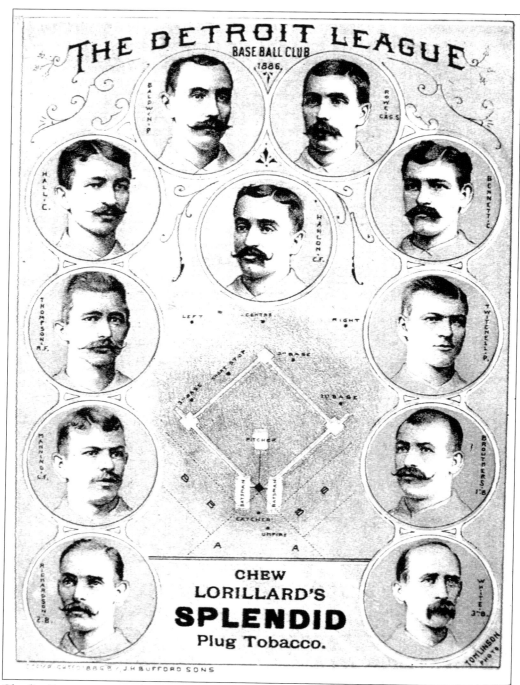

Charlie Getzein was our favorite pitcher through the 1880s. From 1885 to 1888, "Pretzels" was Detroit's most reliable hurler, with consecutive seasons winning 12, 30, 29, and 19. His .690 winning percentage led the league in 1887, but, oddly, he does not appear in the team collage above. Depicted is an advertising card for chewing tobacco, featuring portraits of the 1887 club

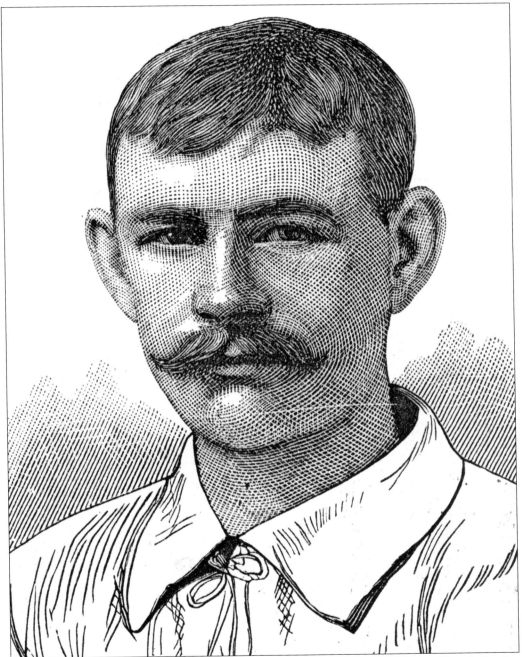

but omitting Charlie Getzein, the anchor of the pitching staff. Instead, Larry Twitchell, who ended up with an 11-1 record in a very successful and very lucky rookie year, was included.

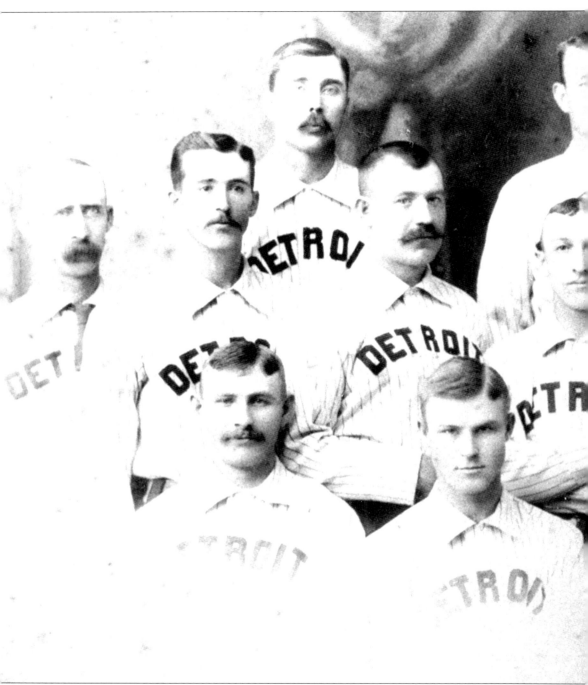

Here are the champs! We had such fun watching this team in that magical 1887 season. These guys knew each other well, had developed team instincts, and on good days looked just like a smooth-running machine. Everything came together for five months in 1887, with pitching stars Charlie Getzein (front row, far left), Larry Twitchell (front row, second from left), Pete Conway (center middle row), Stump Weidman (top row, far right), and Lady Baldwin (top row,

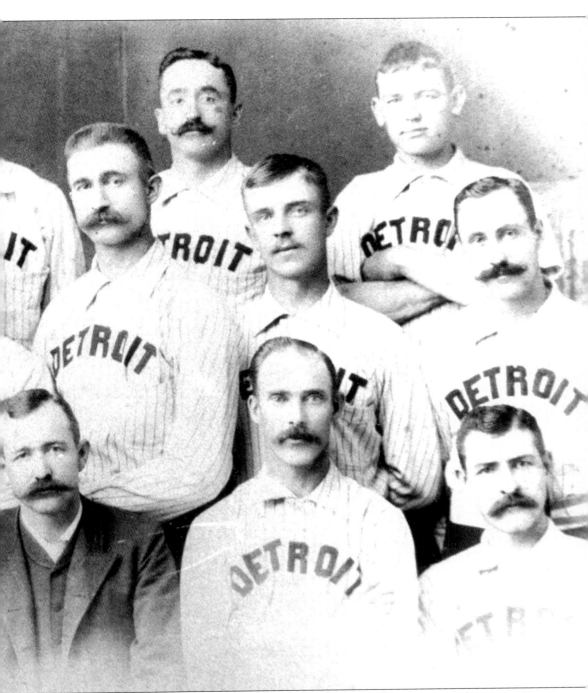

second from left), all big contributors to their triumph. The "Big Four" hitters are here, too: Dan Brouthers (middle row, third from left), Sam Thompson (middle row, third from right), Jack Rowe (top row, far left), and Deacon White (middle row, far left). This quartet made the opposition pitchers nervous day in and day out. Manager Bill Watkins always wore a sad expression, but this group had to make him happy.

This is an example of the illustrated, lithographed, colorful covers that decorated the scorecards sold outside Bennett Park. The lineups for the day were printed inside, so fanatics could keep a record of the game.

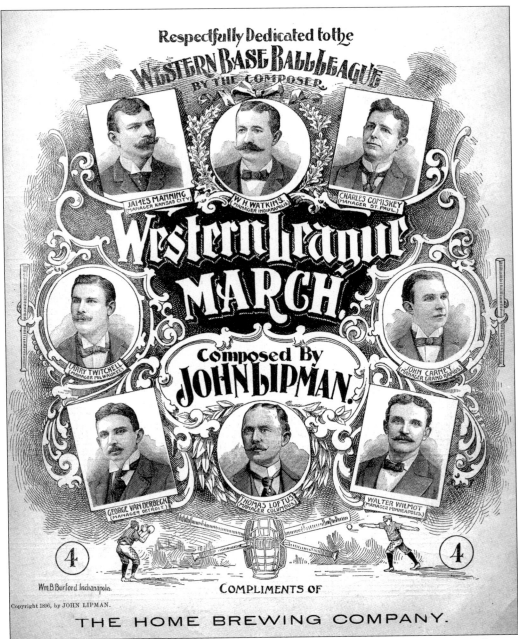

Back before the Tigers, and after the Wolverines folded in 1888, Detroit had a baseball team in the Western League. The old league even had a marching song, as illustrated here. This sheet music cover was printed in 1896, when Ban Johnson was league president. In a few years, Johnson would transform the shaky conglomeration of teams into the American League. Pictured at lower left is Detroit manager George Van Derbeck, who was with the club during the mid-1890s. He was not major-league material, as we fans wanted him to be. We knew baseball was popular in our city and that we could compete with anyone; we just needed a financier and a berth in the National League.

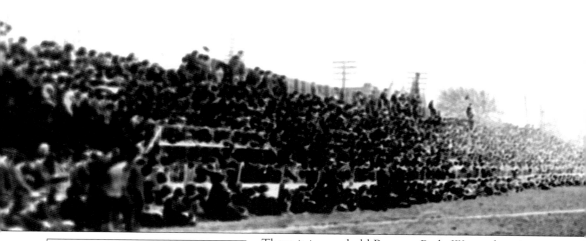

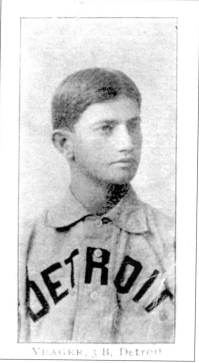

There it is, good old Bennett Park. We used to sit in the bleachers along the first-base line and watch our favorites on the mound. Little Joe Yeager (left) started his career in the 19th century with Brooklyn but became a Tiger in 1901. He went 12-11 in his first year in the American League. After having only won six more games by 1903, he soon retired. Ed Siever (opposite page, left) had two early stints with the Tigers. In 1901, he won 17 games, and in 1902, he won 8. He returned to Detroit in 1906 and closed out his career with 13, 17, and 2 wins in the seasons through 1908. Red Donohue (opposite page, right), after a long career with five other teams, showed up in Detroit in 1906 and won 14 games for the Tigers in his last professional season.

YEAGER, 3 B, Detroit

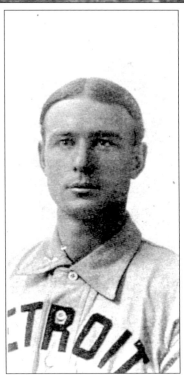

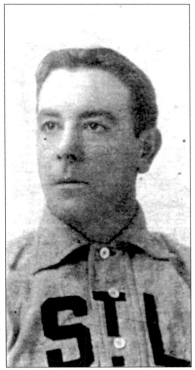

WIN MERCER
CAREER 1894–1902 DETROIT 1902

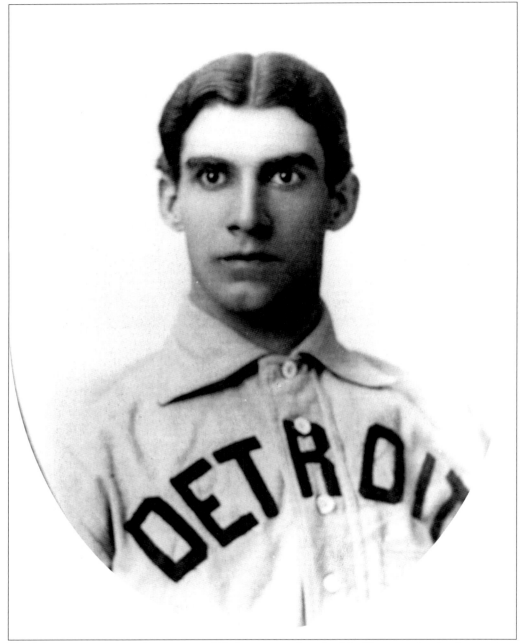

Win Mercer spent most of his career in Washington and pitched for Detroit in his final campaign, winning 15 games in 1902. The Tigers appointed Mercer player-manager for 1903, but the Chester, Pennsylvania, native killed himself by inhaling poisonous gas before the season had begun. He blamed women and gambling for his problems.

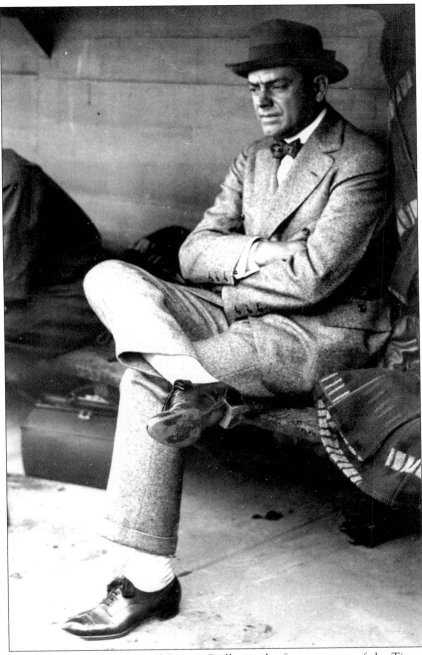

Above is an in-the-dugout portrait of George Stallings, the first manager of the Tigers in 1900 and 1901. Stallings was unceasingly intense on the field, viciously riding his players during each contest. He worked hard to get the most out of his club, and he brought the Tigers to a fourth-place finish in 1900 with a 71-67 record. Things got a little better the following year when a 74-61 finish brought the team to third place in the American League. Stallings was to later gain national fame when he led the "Miracle" Boston Braves to a pennant and then a World Series championship in 1914, after adopting a more conciliatory leadership technique.

"WILD BILL" DONOVAN
CAREER 1898–1918 DETROIT 1903–1912

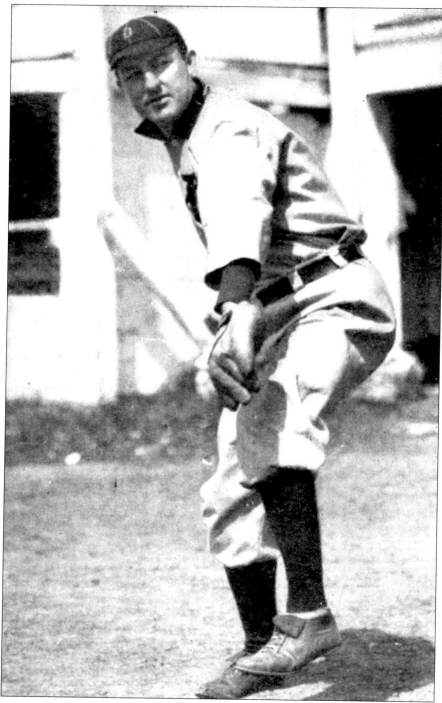

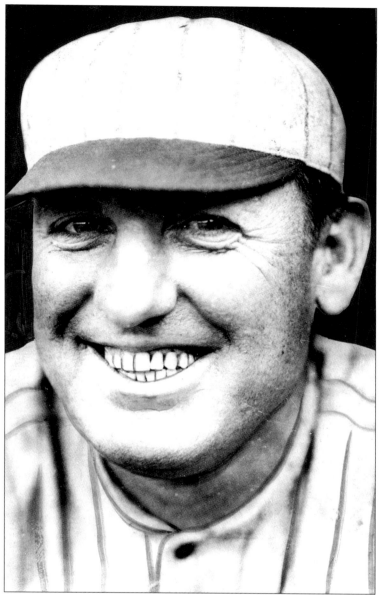

Bill Donovan was a fan favorite and no wonder. He *was* wild, having had control problems throughout his career. But he had a rubber arm, completing 289 of the 327 games he started in his 18-year career. In 1903, Donovan was welcomed to Detroit, where he soon became a 17-game winner. He notched an identical 17-16 record in 1904, but did not win 20 until the pennant-winning year of 1907. His 25 victories were best in the club, good enough to lead the American League with an .862 winning percentage. He stayed with the Tigers until 1912, so he got to participate in three World Series but without much success. In those three Series, he logged a 1-4 record, with a lower ERA than he was accustomed to. Returning to Detroit for an attempted comeback in 1918, after two seasons with the New York Highlanders, we saw the end was near. He closed out his career with 187 wins, before becoming a manager soon after retiring. He died in a train wreck, while sleeping, in 1923.

Frank Kitson

Career 1898–1907 Detroit 1903–1905

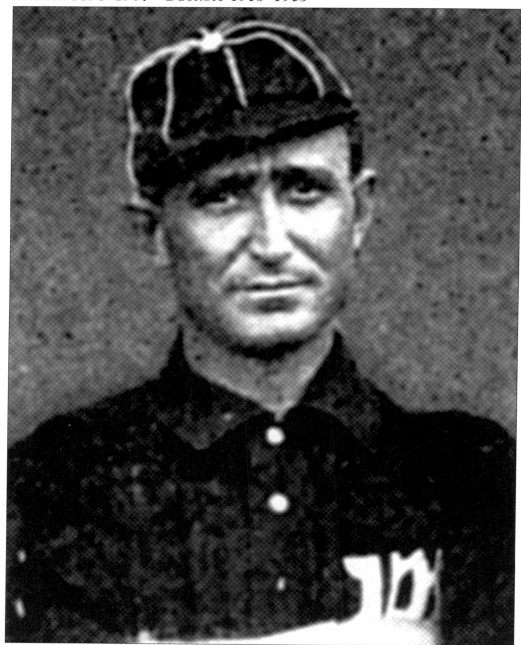

Right-handed hurler Frank Kitson likely wore his arm out in Baltimore and Brooklyn before arriving in Detroit. He threw 329 innings for the Orioles in 1898 and, in three seasons with the Trolley Dodgers, endured 283 innings in 1900, 312 in 1901, and 251 in 1902. He was certainly tired when he arrived in Detroit in 1903 but still managed to put together a 15-16 finish in his

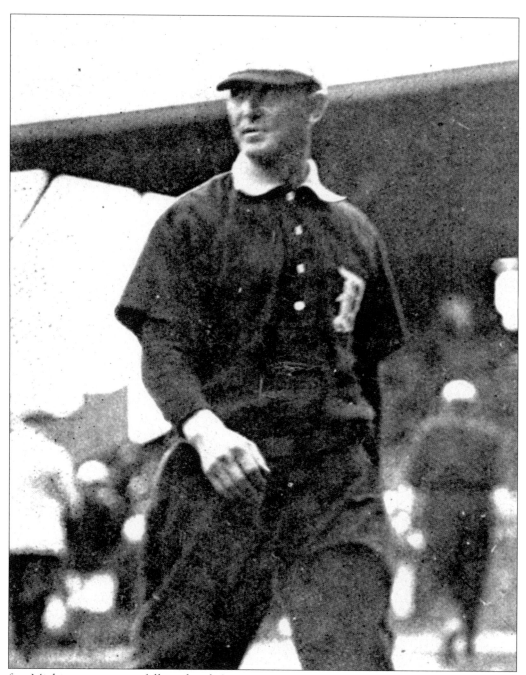

first Michigan campaign, followed with 8 wins in 1904 and 11 in 1905. He managed 129 wins in his 10-year career, additionally throwing for the Yankees and Senators before retiring in 1907. The beautiful blue-and-white uniform seen above was reserved for the road in 1905 and 1906.

GEORGE MULLIN
CAREER 1902–1915 DETROIT 1902–1913

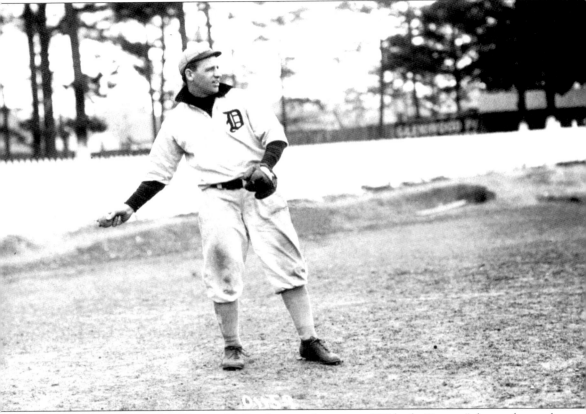

It was in Indiana that George Mullin became known as "Wabash George," from whence he began a long and successful career with the Tigers. In 1905, Mullin hit his groove and proceeded to win 21, 21, 20, 17, 29, and 21 from 1905 to 1910, as consistent as any big winner in the majors. His 29 victories in 1909 led the American League, as did his .784 winning percentage. We loved the big right-hander, especially when he used his blazing fastball in a pinch.

ED WILLETT

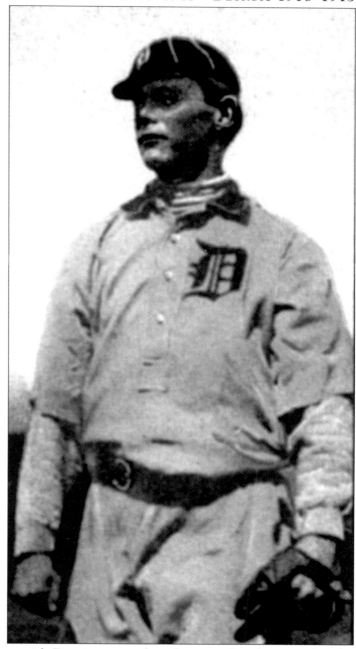

Ed Willett spent all his seasons with Detroit, except those last two when he jumped to the Federal League. He won 96 games for the team over those eight campaigns, with his best being 1909 when he won 21. Over the years, he made four World Series appearances but never had a decision. When he was done in 1915, he had racked up 102 wins.

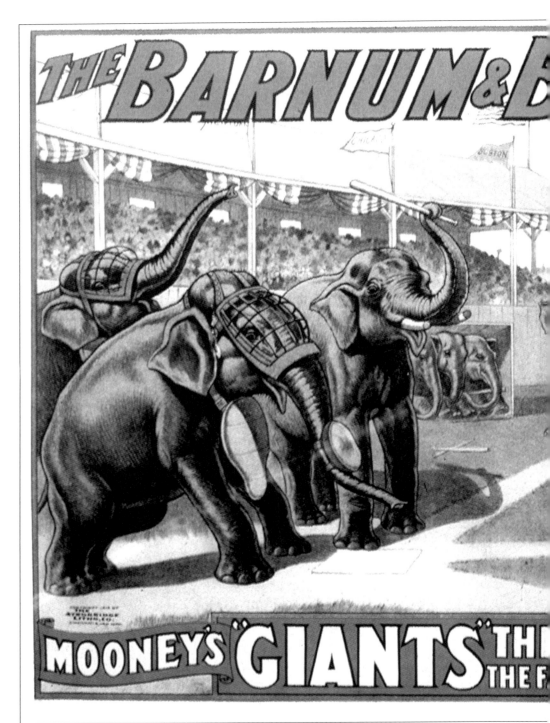

One of the highlights of the years 1900–1910 was the annual arrival of the circus in town. The biggest and best was the Barnum and Bailey show, which had something new every year. Our favorite feature was the elephant baseball extravaganza of 1912. The trainers had taught the

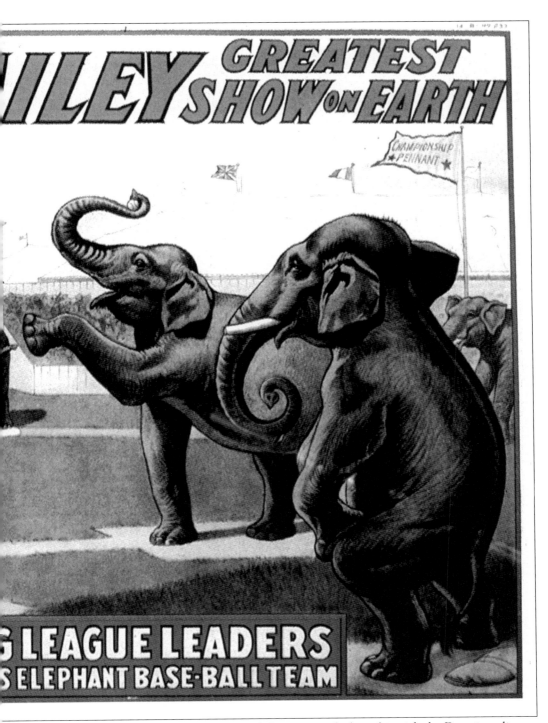

elephants to pitch and bat; the results were hilarious—and a huge hit with the Detroit audience. The circus plastered this poster all over town and, as usual, had a huge draw at the performances. People hoped for trained baseball tigers upon the next visit.

OWEN BUSH S. S.

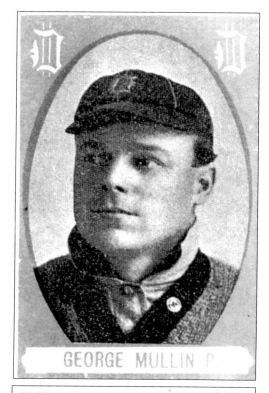

GEORGE MULLIN P.

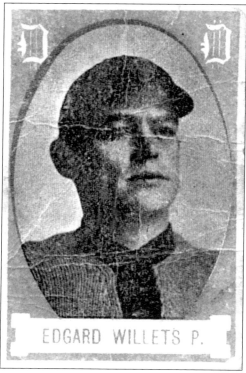

EDGARD WILLETS P.

MATTY MC. INTYRE L. F.

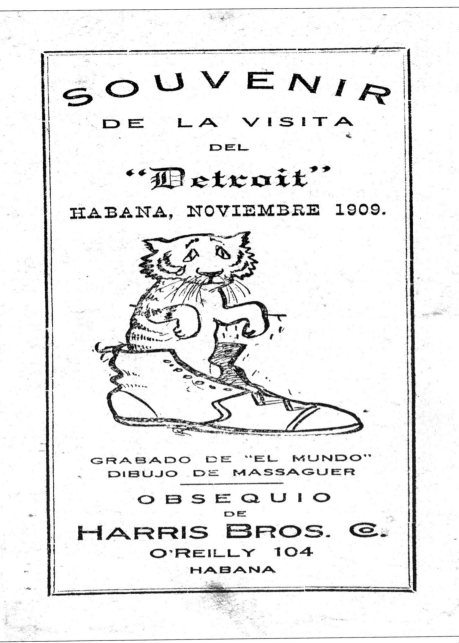

SOUVENIR
DE LA VISITA
DEL
"Detroit"
HABANA, NOVIEMBRE 1909.

GRABADO DE "EL MUNDO"
DIBUJO DE MASSAGUER

OBSEQUIO
DE
HARRIS BROS. C.
O'REILLY 104
HABANA

What a fabulous time we had during those three consecutive pennant seasons starting in 1907. Our team was the toast of baseball, and young Ty Cobb was at the center of it all. After the 1909 season, the ball club went barnstorming, without Cobb or Sam Crawford, on tour to Havana, Cuba, for a series of games on the baseball-crazed island. George Mullin and Ed Willett pitched in the series and were depicted on Cabañas cigarette cards, commemoratives for Cuban fans, along with 10 other Tigers. A local entrepreneur even issued a booklet with information for the fans in la Habana, with biographies of the players and coverage of the games, including box scores.

ROSCOE MILLER
CAREER 1901–1904 DETROIT 1901–1902

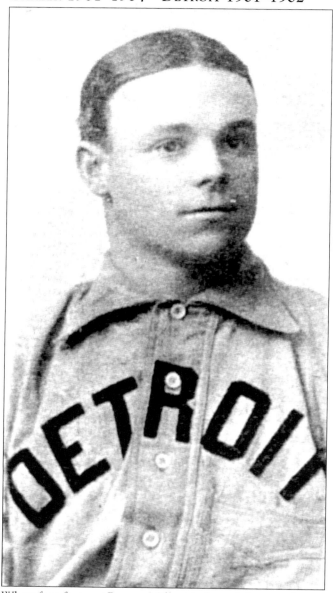

When fans first saw Roscoe Miller pitch, and then saw his success as a rookie in Detroit in 1901, they thought he would be around for a long time. He recorded a 23-13 win-loss record that first year, but in 1902, the numbers looked much worse, at 7-20. It appeared opposition hitters had figured him out, and he was shipped to the Giants the following year. In the photographic collage, opposite page, a number of Tiger pitchers are featured, including Bill Donovan (second row, center), Ed Summers (first row, center) and George Mullin (first row, right). This image appeared in one of Spalding's instructional publications, which fans bought religiously every year off the drugstore magazine rack.

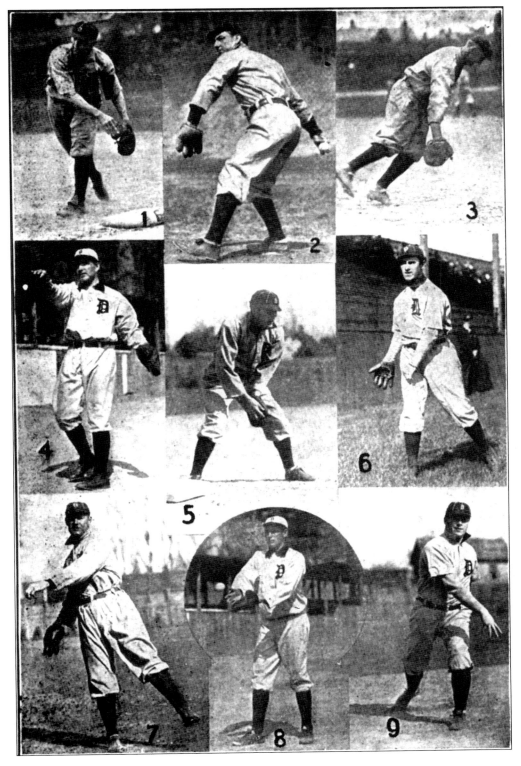

35

𝔒𝔣𝔣𝔦𝔠𝔦𝔞𝔩 𝔖𝔠𝔬𝔯𝔢 𝔠𝔞𝔯𝔡

𝔚𝔬𝔯𝔩𝔡'𝔰 𝔠𝔥𝔞𝔪𝔭𝔦𝔬𝔫𝔰𝔥𝔦𝔭 𝔖𝔢𝔯𝔦𝔢𝔰

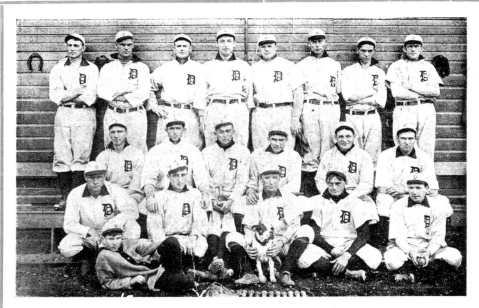

DETROIT "TIGERS," 1907

Top Row— Eubanks Rossman Crawford Donovan Mullin Willits Payne Killian
Middle Row— D. Jones Downs Cobb Coughlin Schaefer E. Jones
Bottom Row— Siever Archer Jennings Schmidt O'Leary
O'Brien, Mascot Reading from Left to Right

DETROIT "TIGERS"
AMERICAN LEAGUE
VS.
CHICAGO "CUBS"
NATIONAL LEAGUE

H. M. FECHHEIMER, PUBLISHER, 166 WOODWARD AVE., COR. GRATIOT. PHONE M. 1675

Above is the program sold at the 1907 World Series, which we saved for all these years. The Tigers were wiped out by the Cubs, but every postseason is exciting, and everyone had great fun.

ED SUMMERS
CAREER 1908–1912 ALL IN DETROIT

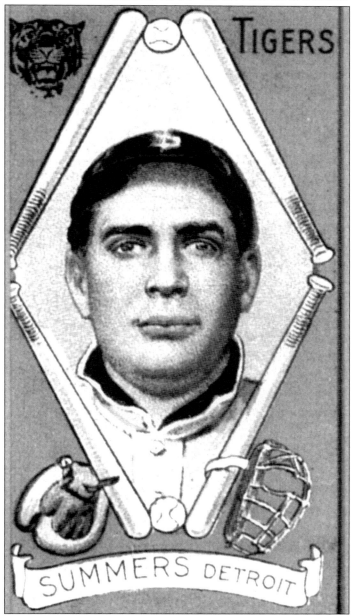

Shown here is a copy of the 1911 Ed Summers tobacco card from a pack of Sovereign cigarettes. This kind of Tiger memorabilia can be found all over the 28 square miles of the city. Summers was another of those rookie phenoms who came to Michigan in the early 1900s. He finished a startling 24-12 in 1908 but slowly declined thereafter, retiring with a 65-45 record. His most amazing game was against the Senators, when he threw an 18-inning seven-hitter ending in a scoreless tie. He did not get a win in either the 1908 or 1909 World Series.

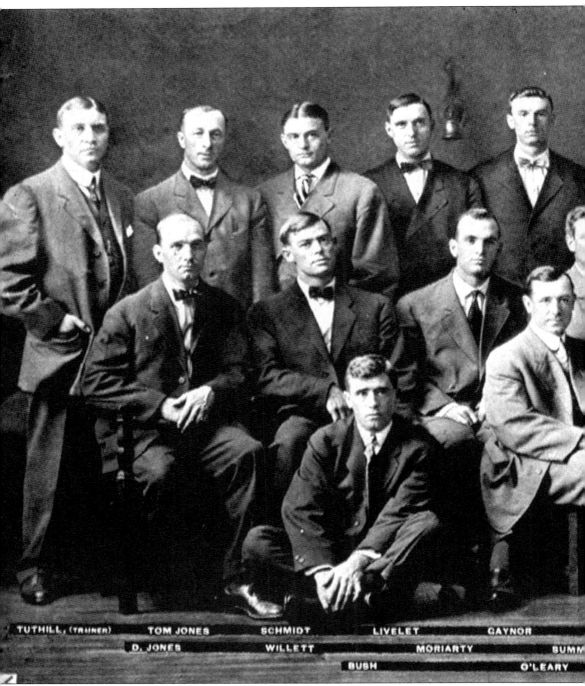

TUTHILL, (TRAINER) TOM JONES SCHMIDT LIVELET GAYNOR

D. JONES WILLETT MORIARTY SUMM

BUSH O'LEARY

This beautiful 1909 premium, from the *Sporting News*, shows Detroit's heroes as they appeared off the field. This was the last pennant-winning group in the decade, garnering 93 wins, the most of any team from 1907 to 1909. Three pitchers who should be mentioned are photographed here with the team. In the top row, fourth from left, is Bill Lelivelt, who worked only two years in the majors, both in Detroit. Ralph Works, middle row, second from right, had a somewhat longer

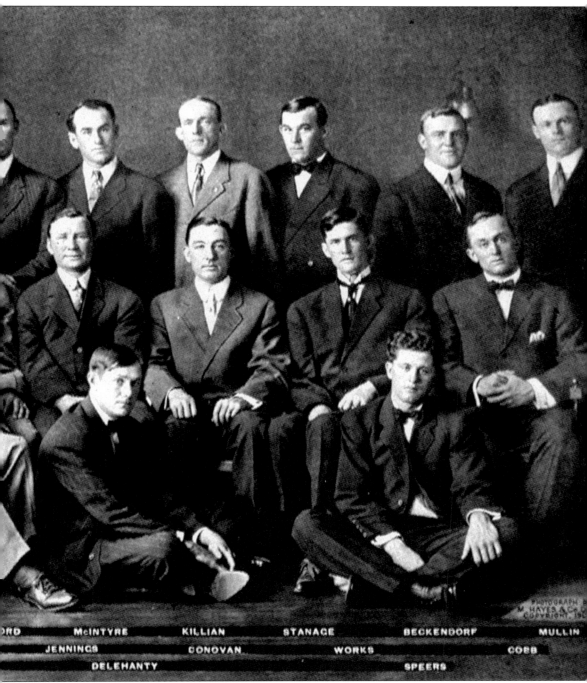

RD McINTYRE KILLIAN STANAGE BECKENDORF MULLIN

JENNINGS DONOVAN WORKS COBB

DELEHANTY SPEERS

career, hurling for Detroit from 1909 to 1912, winning 24 games over that stretch. Kid Speer, bottom row, far right, lasted only 12 games in Detroit in 1909. His 4-3 record was decent, but he never saw the major leagues again. In all, the Tigers used eleven pitchers to take the flag in 1909 and then only five in the World Series, which they lost to the Pirates, 4 games to 3.

"At the Old Ball Game" was probably the ugliest Tiger sheet music ever issued, and the song was not much better.

Those Long, Hot Summers
1916–1930

When the Tigers were winning, the summers didn't seem as hot, or at least we fans didn't spend much time talking about the heat. But those seasons of struggle, starting in 1915, seemed unpleasantly steamy and long. Everyone got through it, but we were as annoyed as entertained.

By 1914, the thrills of the previous decade were decidedly over. Personnel had changed considerably; although Ty Cobb and Sam Crawford were hitting mainstays and the Hall of Fame manager Hughie Jennings was still with us in 1915 (1907–1920 was his tenure), there was a new staff of starting pitchers, and, most of all, there was hope. That hope translated into a second-place finish in 1915, after posting a spectacular 100-54 record, ending up one frustrating game out, one measly game behind the Boston Red Sox. Harry Covaleskie and Hooks Dauss won over 20 games each that year, and Cobb led the league in hitting again. By 1916, we were starting to slip, as we managed only 87 wins that year, 13 fewer than the year before. And it would only get worse in 1917 and 1918, as the White Sox and Red Sox were dominating the American League. Still, we loved and followed our Tigers and attended many games, but in the second decade of the 20th century, baseball excitement was not often found at Navin Field, the Tiger's home, which replaced old Bennett Park in 1912.

By 1920, Cobb took over as manager, a move that many fans thought was a foolish one. Cobb could play like no one else, and no one hated to lose more than the "Georgia Peach," but his communication skills were limited, and his temper was a constant problem. From 1921 to 1926, he guided the team, with his highest finish being second place in 1923 (83-71) and his highest win total in 1924 (86), when the Tigers finished third. George Moriarty replaced Cobb as manager for the 1927 and 1928 seasons, but things got worse. In 1929, Bucky Harris took over and led the team into the 1930s, but he never saw success with the Tigers, either. The fans had hoped his triumphs with the Senators back in 1924 and 1925 would carry over. Harris's developmental work with the club, and the young players he brought in, would bring pennants later on in the 1930s, but he would not be around to reap the rewards.

JEAN DUBUC
CAREER 1908–1919 DETROIT 1912–1916

The primitive portrait above is from a Cracker Jack baseball card from 1914. "Chauncey," as Jean Dubuc was called, played most of his career in Detroit, winning 72 games for the Tigers. Dubuc was the National League leader in relief victories in 1919 and was subsequently banned from baseball for his connection to the Black Sox scandal.

"HOOKS" DAUSS
CAREER 1912–1926 ALL IN DETROIT

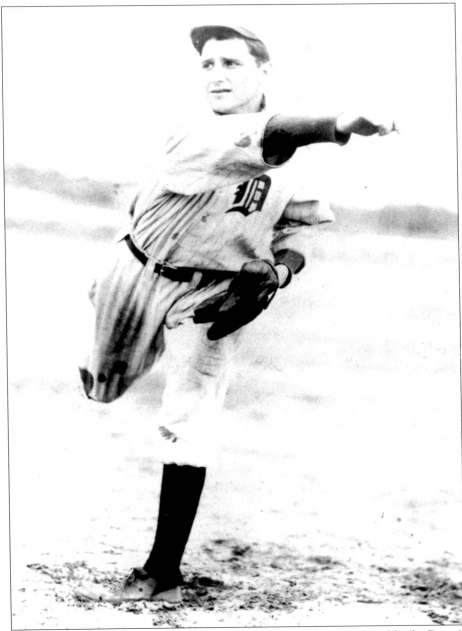

Could it be his curveball that gave George August Dauss his nickname? And could it be Dauss's longevity in Detroit that made him a favorite and ever-reliable pitcher for 14 seasons? He compiled 221 victories and a .547 winning percentage in a career that saw him win 20 games thrice and 19 once. But Dauss did not always have control of that bender, as his 10th-place finish on the all-time hit batsman list attests.

HOWARD EHMKE
CAREER 1915–1930 DETROIT 1916–1922

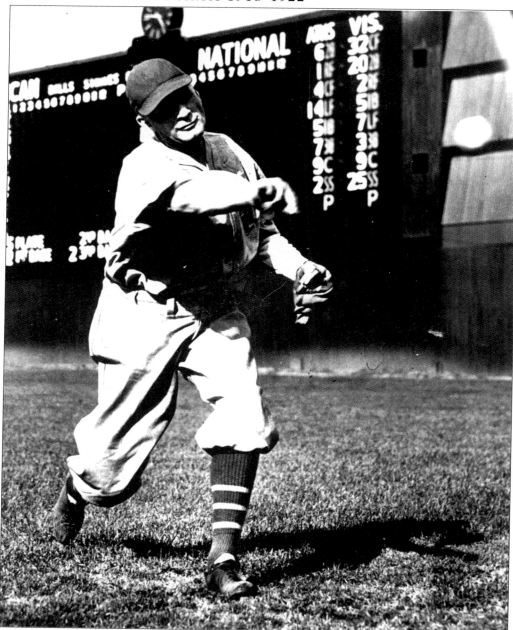

Howard "Bob" Ehmke established himself as a solid major-league starter after his six seasons in Detroit. He was snatched up after the Federal League folded, where he had pitched for Buffalo. He threw sidearm and submarine pitches, and his junk was quite effective against right-handers.

HARRY COVALESKIE
CAREER 1907–1918 DETROIT 1914–1918

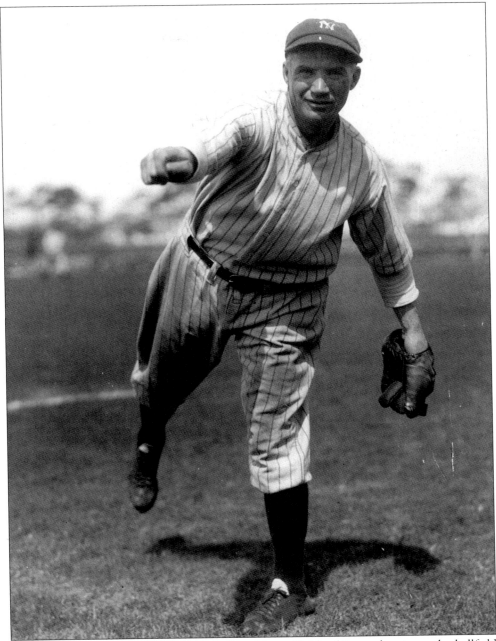

Harry Covaleskie was raised in the rough-and-tumble coalfields of Pennsylvania, so the ballfield was a picnic for him and his two athletic brothers. After leaving the Reds in 1910, he resurrected his career with the Tigers in 1914 and began a string of three superb seasons, winning 21 in 1914, 23 in 1915, and 22 in 1916.

ED WELLS

CAREER 1923–1934 DETROIT 1923–1927

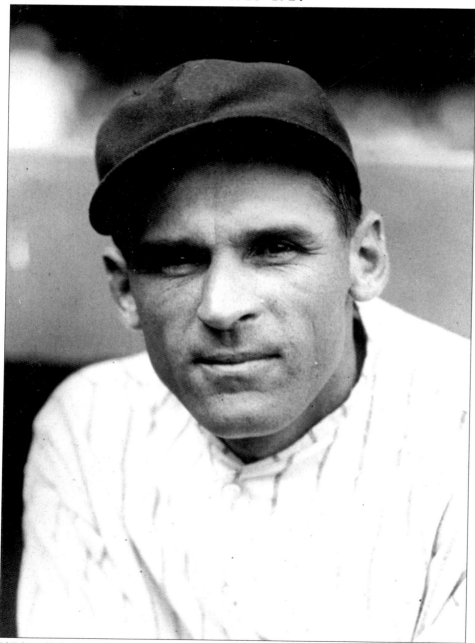

If Ed Wells had not been a left-hander, he would likely never have pitched in the majors. When Ed started a game or came on in relief, it always worried everyone a bit, yet he did get 12 wins in 1926. But he hurt his arm late that season, won but one game the next year, and then didn't resurface again until 1929 with the Yankees.

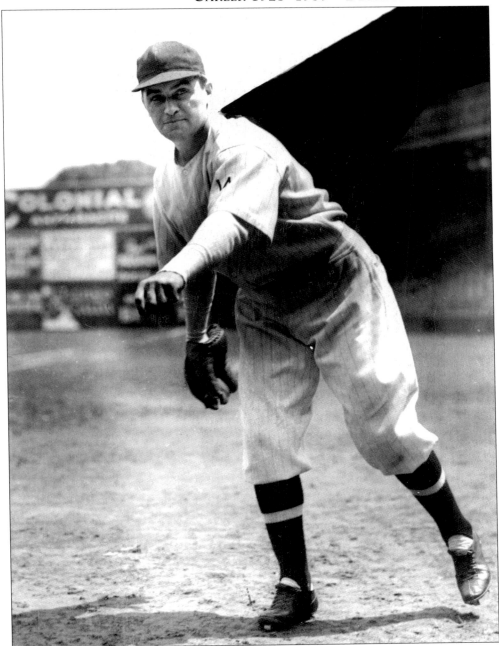

Earl Whitehill was never shy about expressing himself to reporters, fans, or even his manager. He would take nothing from manager Ty Cobb, standing up for himself in the exchanges the two had over the years. Whitehill won lots of games for Detroit—137 in 10 campaigns—while giving up about four runs per game started.

George Uhle
Career 1919–1936 Detroit 1929–1933

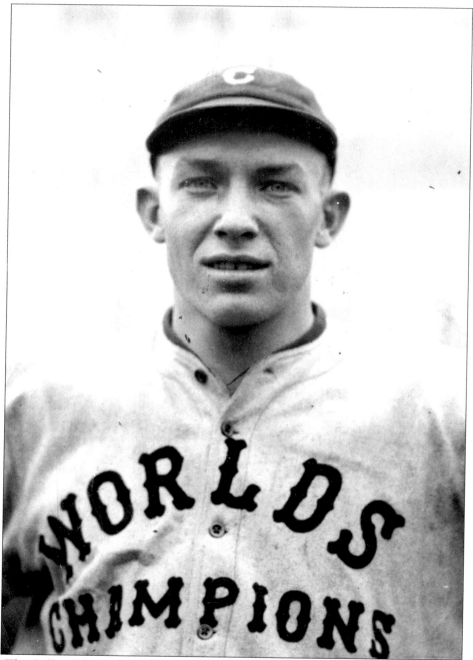

"The Bull" Uhle won 200 games in 17 big-league seasons. Detroit was the second team he pitched for after leaving Cleveland in 1928. He won 44 games for the Tigers in four years, but his arm finally wore out, and he retired in 1936.

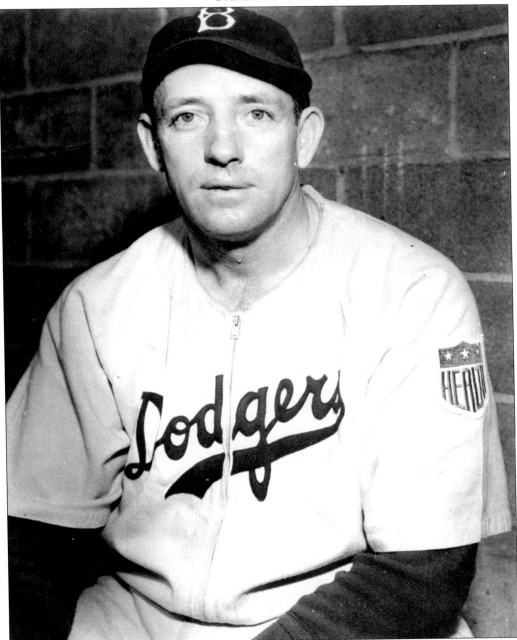

Whit Wyatt pitched 11 years in the majors before he won 20 games in 1941. When he came up from the minors to Detroit in 1929, he was used sparingly. In fact, Wyatt was pretty much unused during his stay with the Tigers. He could be considered as a player that Detroit discovered, then trained, but then let get away.

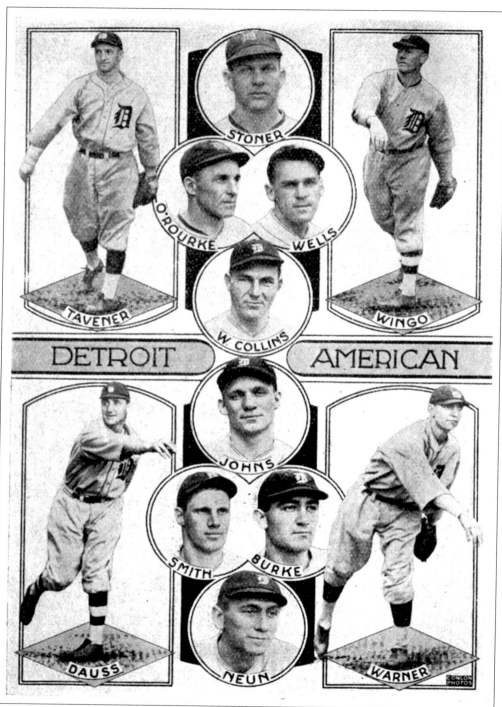

Still others worked on the mound at Navin Field. Ulysses S. Grant "Lil" Stoner (top middle) won 10 games twice in seven seasons in Detroit. Rip Collins (middle) spent 1923 to 1927 in a Tigers uniform, winning 44, mostly as a starter.

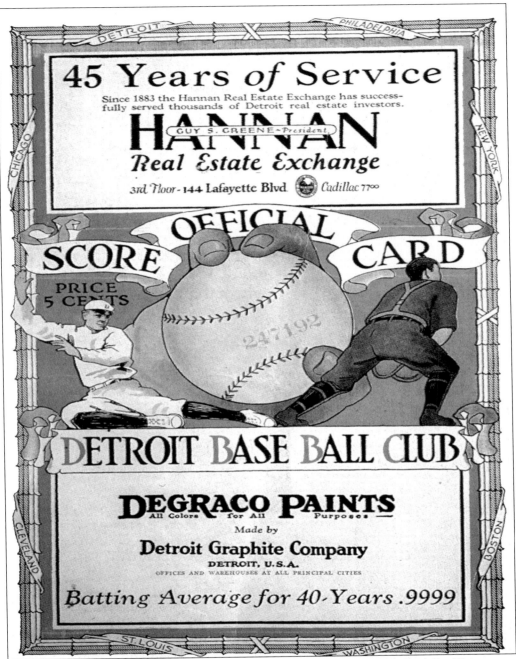

Fans would pick up this program outside the park in 1928 and would dutifully fill it out to keep a record of their attendance and allegiance. Despite the handsome scorecard, old George Moriarty's crew could not muster better than eighth place in an eight-team league, with a 68-86 record. One can guess the fans' mood in Detroit in the late 1920s.

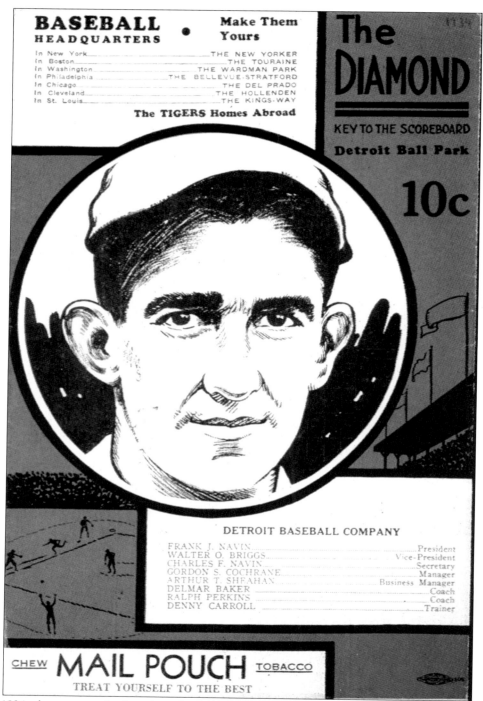

By 1934, the manager had made it from the bench in the dugout onto the cover of Detroit's scorecard. That is Mickey Cochrane whose face stares out at you. Cochrane arrived in 1934 and immediately won a pennant, won another, along with a world's championship in 1935, and followed that with two second-place finishes.

THREE

The Throbbing Thirties

Bucky Harris was hired as the Tigers' manager in 1929 after his success with the Senators back in the mid-1920s. But the plan did not quite work out. Despite the signing of the future longtime stars like Hank Greenberg and right-handed fireballer Tommy Bridges, we still struggled.

As the 1930s began, Detroit was still in the second division, as the Athletics put together their second strong season in a row, relegating the powerhouse Yankees for second place. Owner Frank Navin and Harris worked together to steadily bring in more talent. But we fans in the stands had to be patient, for despite having future Hall of Famer Charlie Gehringer at second base every day, the pitchers toiled hard just to get the team over .500 in 1932, earning a fifth-place finish. With Greenberg in the lineup daily, the fans hoped for better results in 1933, but we did not get them. Harris probably deserves credit for setting up the Tigers for success, but he was fired before the end of the 1933 season, as the Cats ended up in fifth again.

Mickey Cochrane was hired over that winter, and, as if by managerial magic, led the Tigers to a 101-victory finish, resulting in the American League pennant flying on the ballpark roof. That year, Tommy Bridges won 22, Schoolboy Rowe won 24, while Eldon Auker and Firpo Marberry both won 15. Parties were raging all over the city after hearing the team would face the Cardinals in the World Series. We played them tight until game seven, but we went home happy anyway. The call to wait until next year was suddenly a hopeful one. The 1935 season was a joyous one for all Tiger fans, even though the team started slowly that season. By the end of July, we were in first place and cruised into October unchallenged. And then we beat the Cubs in six games in the World Series, with four of those games played right here in Detroit. Cochrane stayed on as manager until 1938, keeping the team near the top but unable to get past the Yankees in 1937 or 1938. Del Baker took over around mid-season of 1938, as the team dropped from second place to fourth. The Tigers closed the 1930s falling to fifth place and for the third-straight year recorded no 20-game winners. But we were not worried, because Baker had a plan.

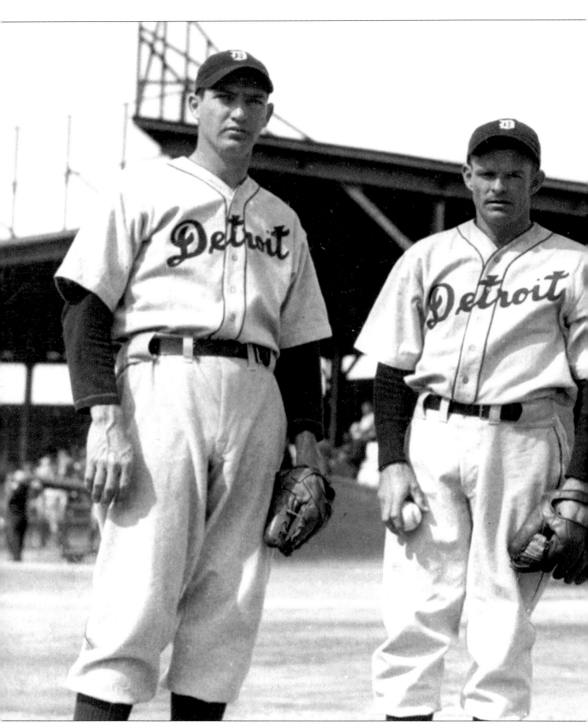

These were the key hurlers who took us all the way to the World Series in 1934, and again in 1935. We relied on them to mow down the opposition, always giving our hitters a chance to win. The photographer posed low to capture the imposing stature of the 1934 starting quartet. Two of the four

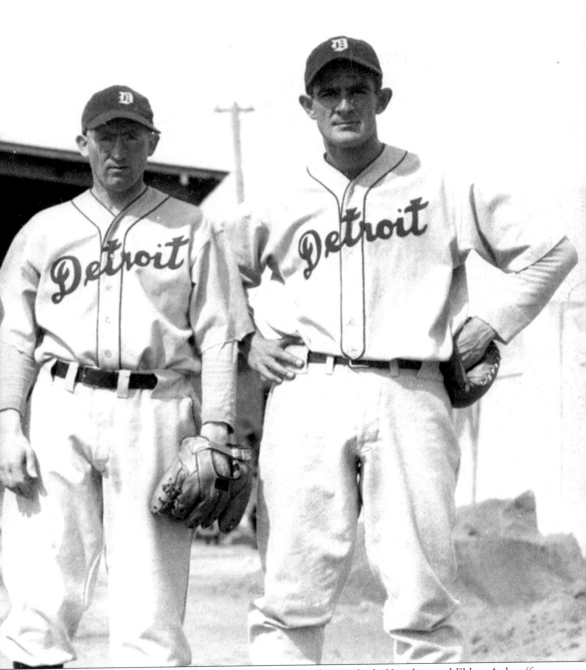

were real giants, Schoolboy Rowe (far left) was six feet four and a half inches and Eldon Auker (far right) was six feet two inches in an era when men were seldom that tall. Our other two heroes in the photograph were Tommy Bridges (second from left) and Vic Sorrell (second from right).

TOMMY BRIDGES
CAREER 1930–1946 ALL IN DETROIT

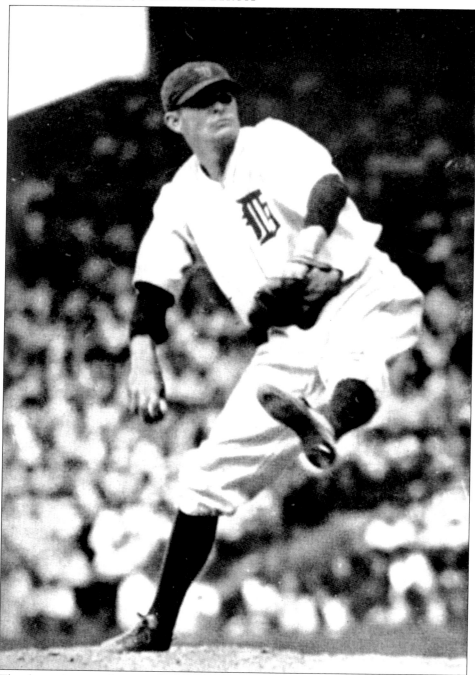

The three-photograph sequence on this and the opposite page show how the 155-pound Tommy Bridges generated his pitching power.

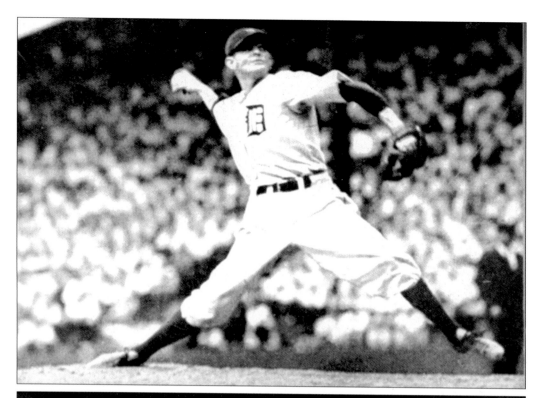

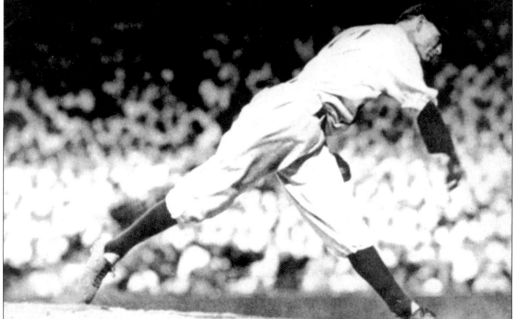

Bridges used a combination of pitches to maintain a starting role in Detroit for a decade and a half, compiling a lifetime 3.57 earned run average. He mixed a lively fastball with a variety of off-speed pitches throughout his Tiger playing days.

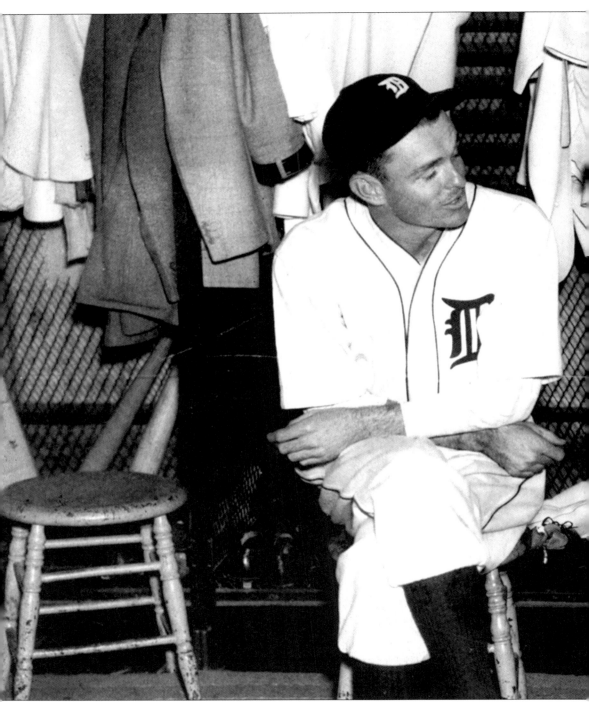

Tommy Bridges is seated here to the left of fellow right-hander Eldon Auker in the Detroit clubhouse in 1933. Bridges pitched for 16 years for the Tigers, winning 194 games, completing 204, and starting 362. He generated lots of power from his small frame and mixed in sharp breaking balls with his speed. He would have won more but was called into military service in

1943 and did not return until 1945. A six-time all-star, he won 20 games three times, including a league leading total of 23 in 1936. Auker, the big submariner from a small farm town in Kansas, was Detroit's number three starter from 1934 to 1938, won 28 games in 1935, and 17 in 1937.

WAITE HOYT
CAREER 1918–1938 DETROIT 1930–1931

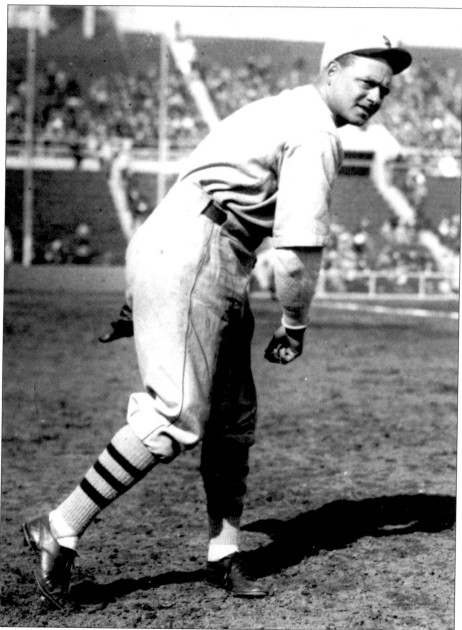

Waite Hoyt's most notable pitching exploits were not with the Tigers but with, of course, the New York Yankees. Without those fantastic statistical years, he would never have made the Hall of Fame. So, we considered ourselves lucky to get to see him for part of two seasons, including most of 1930, when he won nine games, and 1931, when he split the season between Detroit and the Athletics. In the photograph above, Hoyt is wearing the Tigers' 1930 home uniform.

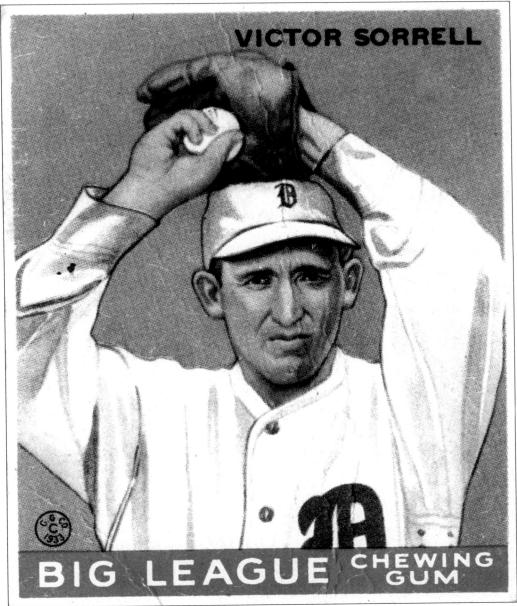

This Vic Sorrell bubble gum card was issued in 1934, a few years past the hurler's prime in Motown. Sorrell served as a starting pitcher for a decade, putting up double figures in wins from 1929 to 1933. By the time the Tigers reached the postseason in 1934, Sorrell was out of the rotation and saw no World Series action.

ELDON AUKER
CAREER 1933–1942 DETROIT 1933–1938

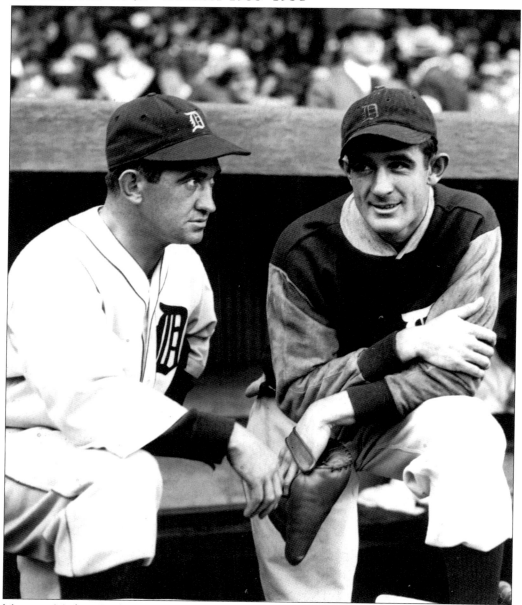

Manager Mickey Cochrane (left) loved to work Eldon Auker and his unusual delivery one day after Tommy Bridges's fastballs were locked in our opponents' memories.

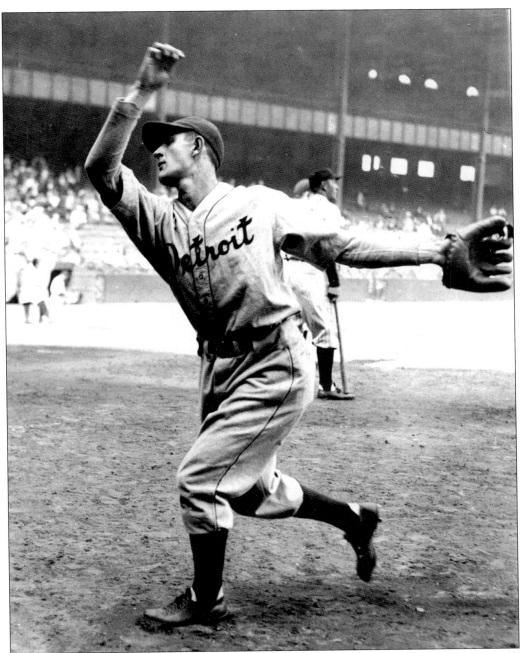

It was a college football shoulder injury that forced Auker to develop his sidearm throwing style. He started game four and seven of the 1934 World Series, getting knocked out in the third inning of the deciding contest against Dizzy Dean. One year later, facing the Gashouse Gang in Detroit's breakthrough campaign of 1935, he started game six of the World Series, pitching well but getting no decision. Auker would later make history by starting in the first night game at home for the Cardinals in 1940.

"SCHOOLBOY" ROWE
CAREER 1933–1949 DETROIT 1933–1942

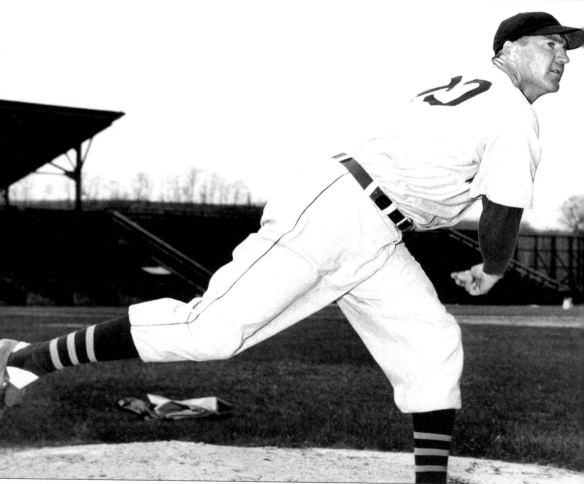

That is manager Mickey Cochrane again talking to a pitcher (opposite page); this time it's Lynwood "Schoolboy" Rowe, who Detroit fans looked up to for an entire decade. Rowe, who got his nickname from his sandlot days, was Detroit's most reliable pitcher in the 1930s, and probably the most photogenic. In fact, every time some celebrity came to the park, they would call out big Lyn to decorate the photograph. Speaking of the park, Navin Field, changes took place there in the winters of 1935–1936 and 1936–1937. Both times the capacity of the park was increased, adding double-decker seating in center and right fields. And when it was all over in 1938, the park had a new name—Briggs Stadium.

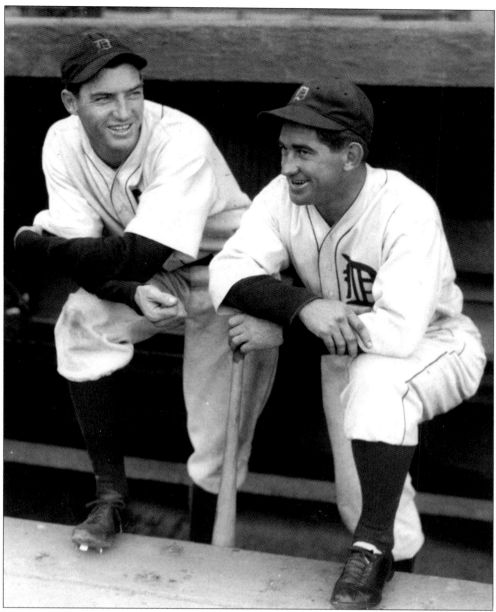

The right-handers, like Rowe, were not pleased, as the alterations turned out to be a boon to lefty batters, who could make a pop-up to right field land in the overhanging upper deck. The World Series year of 1934 was Schoolboy's best, when he won 24, finished 20 of the 30 games he started, and struck out more batters than any other year in his career, 149, which tied him for third in the league. His winning percentage of .734 was second best in the American League, he finished fifth in earned run average with .345, was tied for third in games pitched with 45, and was third in innings pitched at 266. Rowe was 2-3 in World Series starts, with an earned run average under 3.00 over 42 1/3 innings pitched. He lost a tough one to Daffy Dean in the 1934 World Series, giving up fewer hits than Dean in game six but losing 4-3. Rowe closed out his career with the Phillies, having compiled 158 total wins.

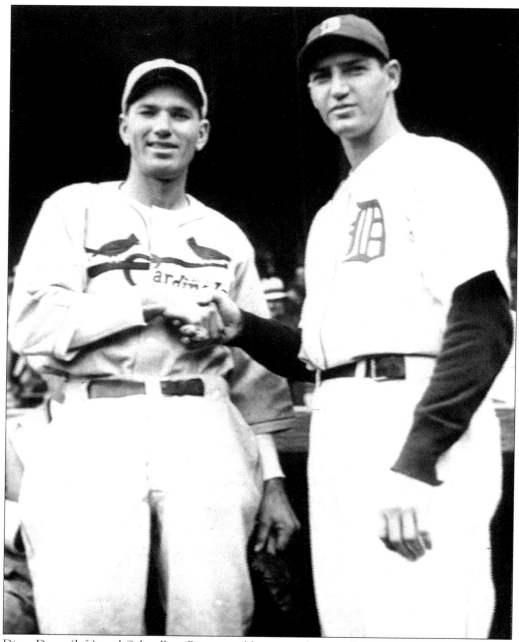

Dizzy Dean (left) and Schoolboy Rowe would get together at all-star games, or before World Series contests. Both were gregarious, both loved the limelight, and both knew this photographic cliché would find its way into the next day's sports pages. Dean and Rowe never faced each other in the 1934 World Series, but the battle between Dizzy's brother Daffy Dean and Rowe in game six that year is still legendary in Motown, especially since over 200,000 people claimed they were there to see it.

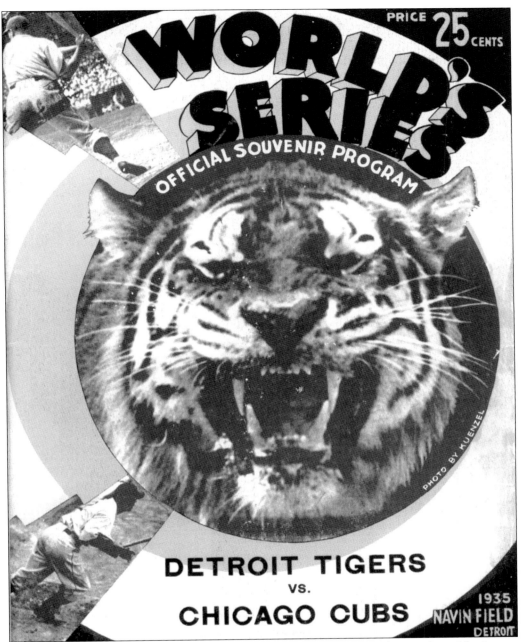

WORLD'S SERIES

PRICE **25** CENTS

OFFICIAL SOUVENIR PROGRAM

PHOTO BY KUENZEL

DETROIT TIGERS
VS.
CHICAGO CUBS

1935
NAVIN FIELD
DETROIT

It looks like the cover for the 1935 World Series Program was put together in about 15 minutes. But, as it was all that was offered, and as the game was scored, and as the publication was kept all these years, it is included here.

"Firpo" Marberry
Career 1923–1936 Detroit 1933–1935

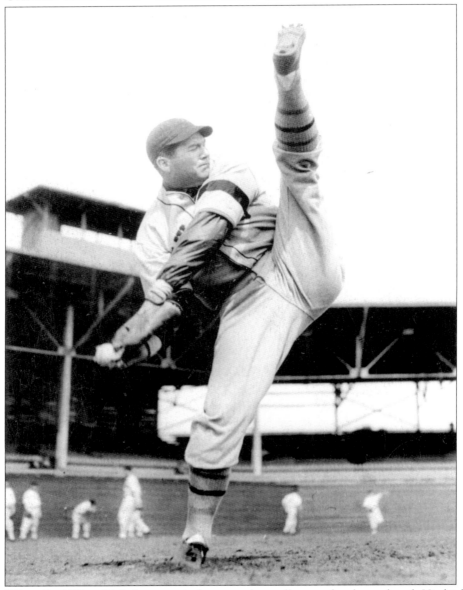

When Fred "Firpo" Marberry took the mound, we all wanted to be on hand. His high leg kick and familiar scowl entertained, while making it hard on opposition hitters. He was only in Detroit for two full seasons, and part of another, but he *was* memorable. In 1933, Marberry won 16 games, tying his season high. Then, one year later, he put up a 15-5 mark, as he was instrumental in the Tigers' pennant drive in 1934. Then a peculiar thing happened. Marberry was persuaded to give up the mound for an umpiring job, abandoning the American League champs as they drove for another pennant in 1935. He lasted but one year as an arbiter, and after a weak return to the mound with two other teams in 1936, his career was over.

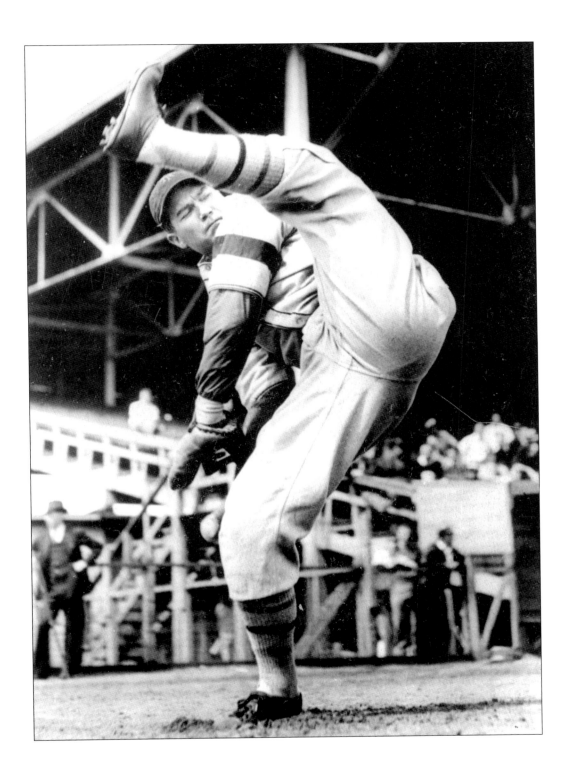

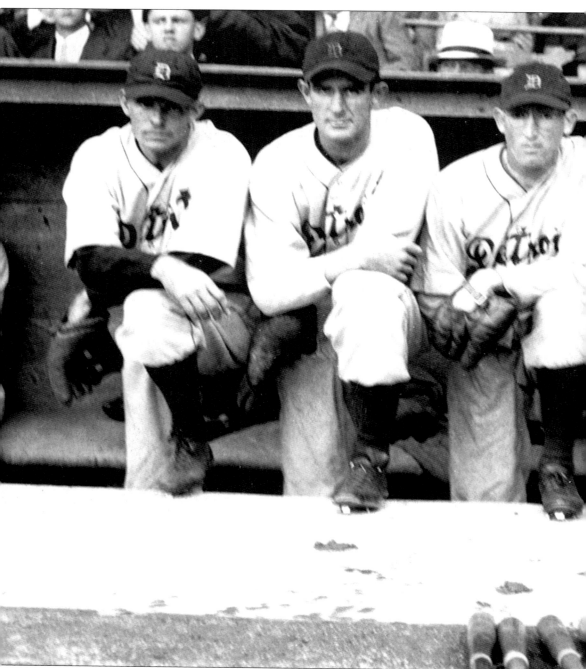

Here is a more complete group of the pitchers who posed during those championship years in the mid-1930s. The lineup here was assembled in 1934, and includes Tommy Bridges, Eldon Auker, Vic Sorrell, Alvin "General" Crowder, Carl Fischer, and Luke Hamlin. Fischer worked for us for three straight seasons, winning 17 games, from both the starter's position and as a reliever, before he was traded to Chicago. Hamlin began his nine-year career in Tiger Stadium, appearing in 23 games during 1933 and 1934. This group won 56 games among them for the Tigers in 1934

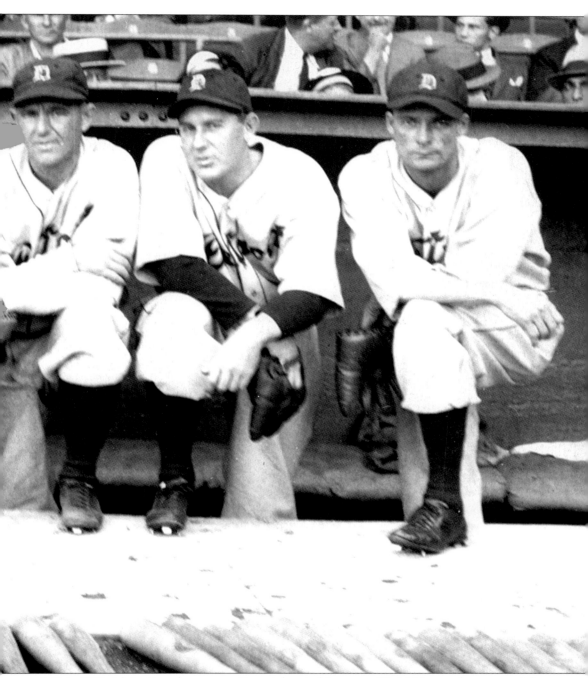

and 59 in 1935. Alvin Crowder came to Detroit late in his career. His 16-10 record was essential to the Tigers topping the Yankees in the 1935 pennant race. He was traded for in the middle of the 1934 campaign, and he went 5-1 to help with the pennant drive that year. He started game one in that Series, facing Dizzy Dean, who won the 8-3 contest to get the Cardinals off on the right foot. He didn't take the mound again in the World Series until the very last inning of game seven, the sixth Tiger pitcher used, when a desperate Mickey Cochrane had run out of arms.

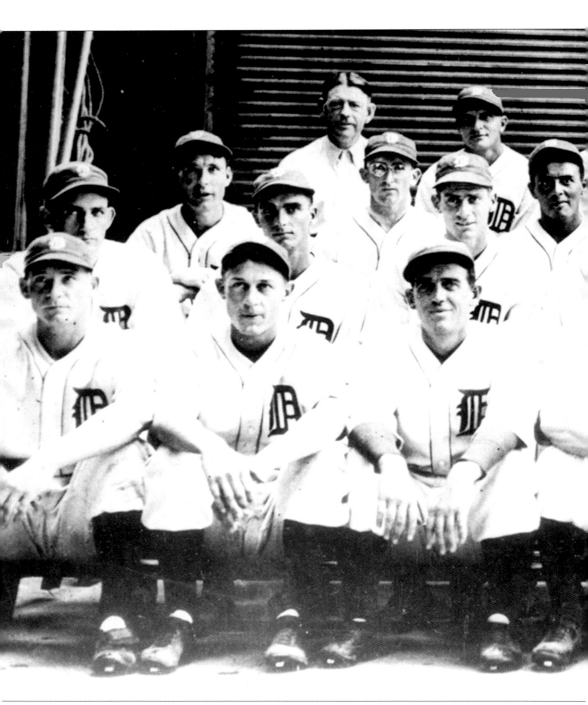

Here are our heroes from 1935. These boys dominated the American League, including the Yankees, and brought home the second pennant in a row and a dramatic World Series victory as well. As you can guess, we celebrated for the entire winter of 1935–1936, with hopes that the onslaught could continue in 1936. Some of our favorites were Schoolboy Rowe, who won 19 games, and Eldon Auker, who won 18, sitting second row, second and third from the right.

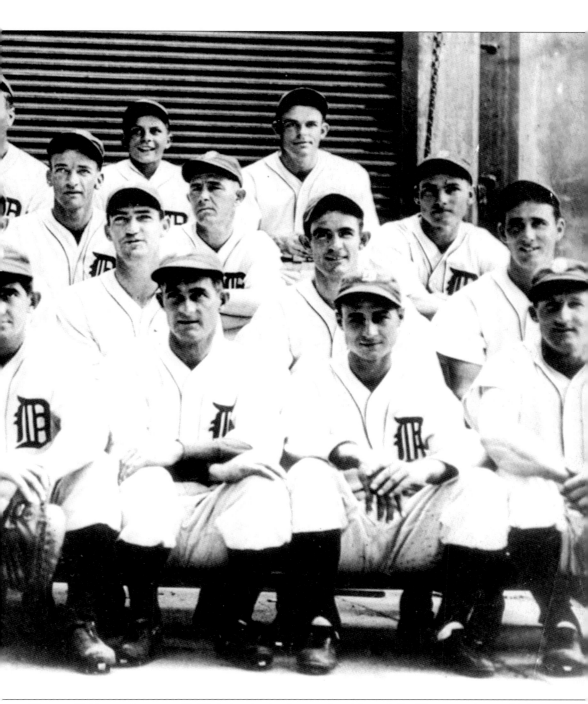

Tommy Bridges, who went 21-10, is in the back row, far right, while 16-game winner Alvin Crowder is second from the right in the second row down. You can also see Goose Goslin, sitting front row, far right, Hank Greenberg just behind him, and Charlie Gehringer in the second row, far left.

"General" Crowder

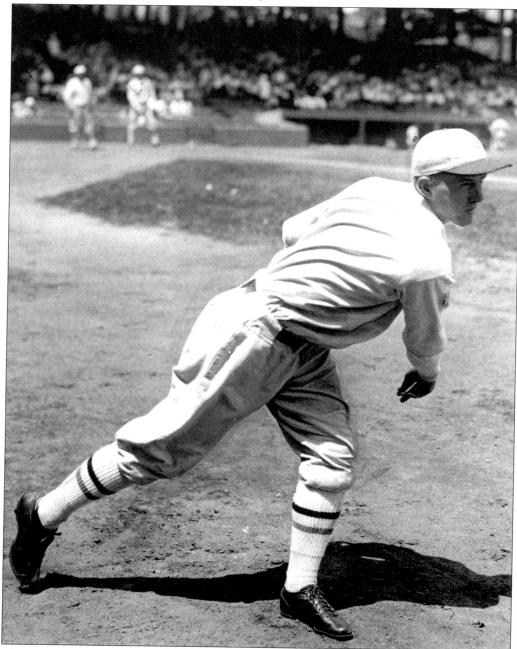

The Tiger parade of great pitchers in the 1930s continues with Alvin Crowder, the crafty right-hander who arrived in Detroit in 1934

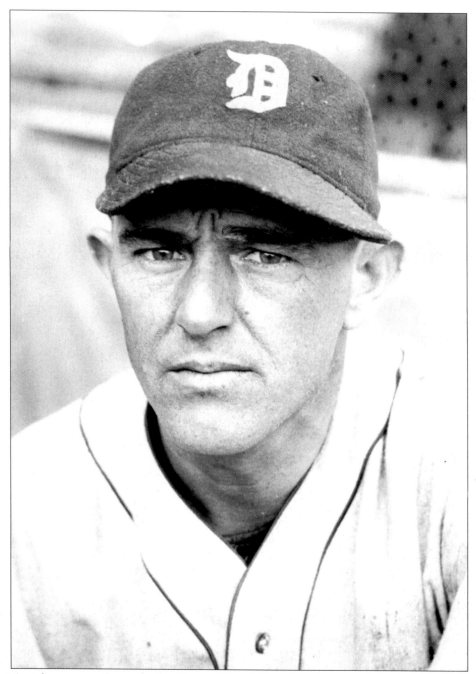

Alvin's nickname was General, after General Enoch Crowder, who started the draft lottery for the United States in World War I. Alvin was a key cog in the Tigers' pennant machines in 1934 and 1935. He came over from the Senators at the end of 1934, winning five games before the season ended. He saw action in game one of the 1934 World Series, as Mickey Cochrane immediately had confidence in him. In 1935, he spent the whole season in Michigan, pitched well throughout, and won key game four in the World Series against the Cubs at Wrigley Field 2-1.

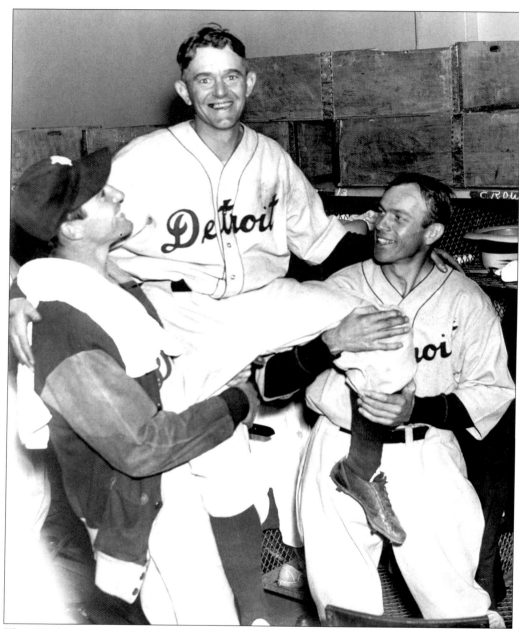

That World Series win in 1935 was as exciting for us fans as it was for the Tigers themselves. Alvin Crowder was no doubt soaked in champagne before this celebratory photograph was taken that October. Hoisting Crowder on their shoulders, after hurling a five-hitter in Chicago, are Schoolboy Rowe (left) and Ray Hayworth, injured bullpen catcher. We did not know it yet, but we would have to wait five years to cheer another pennant winner in Detroit; but that 1935 team was the greatest.

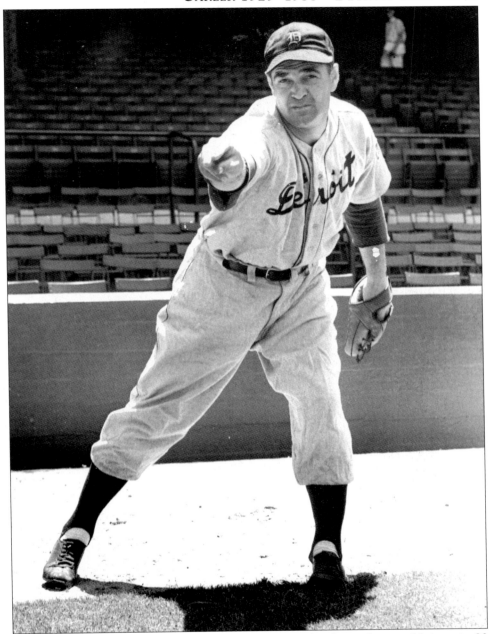

"Bobo" Newsome's career was in transit most of the time, as he changed teams 16 times in 20 years. Since he hardly could keep track of teammates, he called everyone Bobo, and so received the moniker himself. He won over 211 games and lost 222, spending three busy seasons in Detroit, winning 17 in 1939, 21 in 1940, and then losing 20 in 1941. The next year, he was in a Senators uniform.

AL BENTON
CAREER 1934–1952 DETROIT 1938–1948

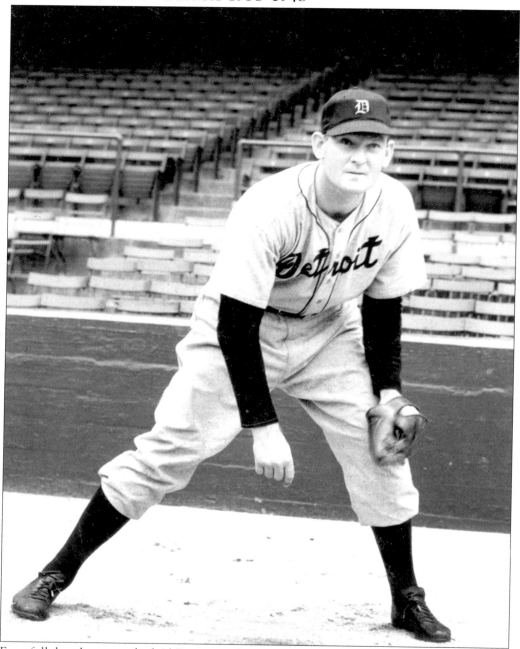

For a full decade we watched Al Benton work the mound for the Tigers, both as a starter and a reliever. Managers used him both as a spot starter and as an innings-eater in high-scoring games. He won a total of 71 games in his time in Detroit, with his best season finding him a 15-game winner in 1941.

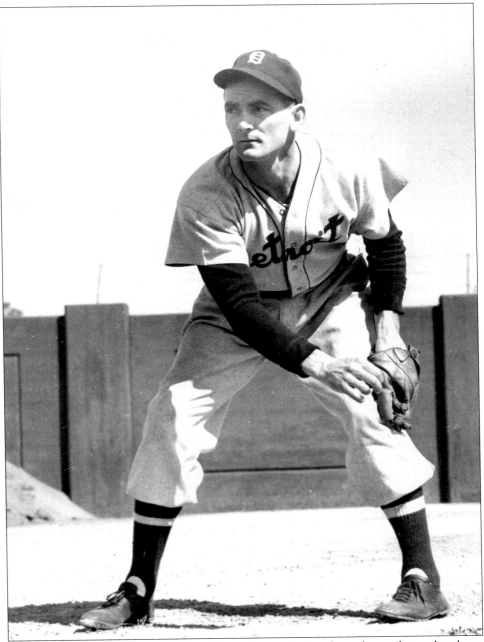

Vern Kennedy looked good to the brass in Detroit, mostly based on the no-hitter he threw for the White Sox in 1935. He did not last long in Detroit, though, arriving in the spring of 1938 and leaving again the next season to go to St. Louis. His 20 losses between the Tigers and Browns led the American League in 1939.

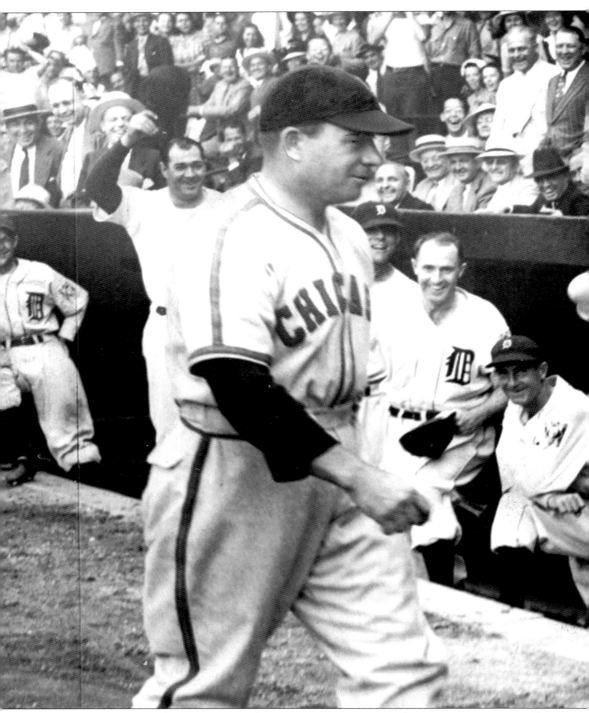

On August 10, 1939, fans got to view this raucous scene. Here is the caption as it appeared in the *Free Press* the next day: "Detroit Tigers got a kick out of this. When Jimmy Dykes was tossed out of Thursday's game in Detroit and was on his way to the clubhouse he was given the usual

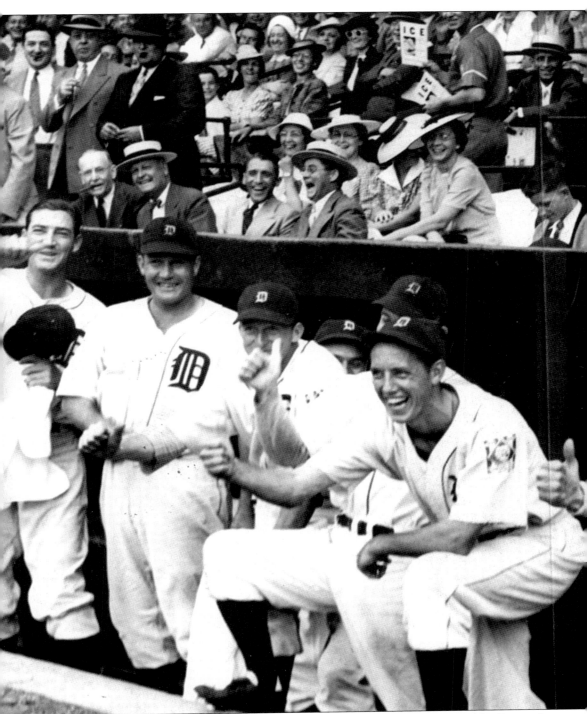

'ride' by the Tigers as he passed the Detroit dugout. Dykes ran afoul of Umpire Eddie Rommel over a decision at the plate, and as usual, lost the argument. Dykes is a noted player 'baiter' and the Tigers did not lose a chance to give Jimmy the works as he walked by."

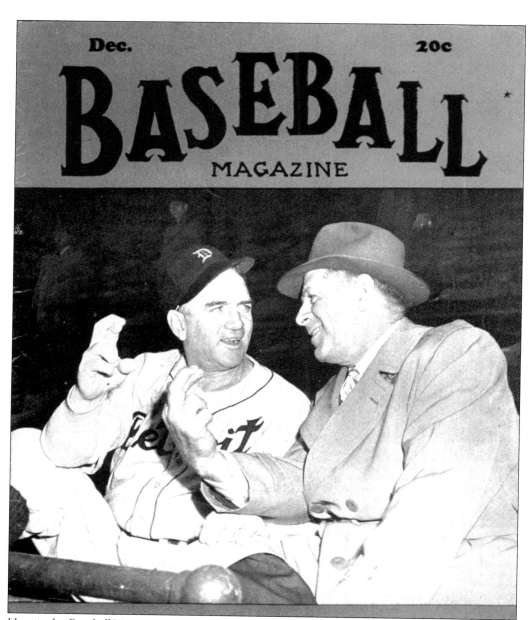

Here is the *Baseball Magazine* cover for the World Series of 1945. That is Detroit's manager Steve O'Neill on the left comparing fastball grips with Charlie Grimm, skipper of the Cubs. Detroit seemed to get over the hump once every five years. They won a pennant in 1935, and after a five-year wait, they won the pennant in 1940, then waited another five years before they could take the flag in 1945. In the above postseason case, O'Neill had a better pitch than Grimm, and a better team.

FOUR

The Fighting Forties and Fifties

Downtown Detroit was hopping in 1940, and the quick trip over to Briggs Stadium was made by trolley, bus, or automobile. The decade began with a 90-64 record, one game better than the Cleveland Indians and two games better than the dreaded Yankees. Del Baker, who had been a catcher for the Tigers way back in 1914, was the manager and inspiration. Our moundsmen dominated the American League that 1940 season, with Schoolboy Rowe and Bobo Newsome finishing one-two in winning percentage. Newsome also was second in wins (21), second in ERA (2.83), and second in strikeouts (164). Needless to say, the fans were pleased.

The past decade had raised expectations in Detroit. We figured the pattern that had been established would repeat itself; namely, that every five years the Tigers would win a pennant. It was true in 1935 and in 1940, so no matter what happened in those intervening years, it was figured, the fans could count on a World Series appearance at the end of the five-year cycle. Things seemed to be going according to plan, as 1941 found the Yankees back on top, while the Tigers fell to fifth place, four games under .500. Everything was in transition with the entry of the United States into World War II, and all major-league rosters underwent continuous rewriting, with players coming and going for four years. We finished fifth again in 1942, Baker's last campaign with the team, but the fifth-place finish again in 1943 was under new manager Steve O'Neill, who, fortunately for the pitching staff, had been a catcher for his 17-year major-league career. O'Neill would stay through the end of 1948. He got the team to a second-place finish in 1944, behind, of all teams, the woeful St. Louis Browns. But we knew 1945 was coming, we were ready for another taste of champagne, and although the team won no more games in 1945 (88) than in 1944, we finished a game and a half ahead of the Senators to take the flag. We faced the Cubs in the World Series and beat them in an exciting seven-game World Series. The pitchers almost won that championship by themselves. As a team, the Tigers hit .223 in the 1945 World Series, but the pitchers, led by the top left-hander of the 1940s, Hal Newhouser, effectively shut down the Cubs' potent offense. O'Neill took the team to two consecutive second-place finishes in 1946 and 1947, but they sank to fifth in 1948. In came Red Rolfe next year, fresh from covering third base for the New York Yankees. But with Rolfe, the team only bounced around the standings beneath the powerhouse Yankees for three seasons. In 1950, with Rolfe at the helm, the five-year cycle was broken. In fact, we would suffer without another pennant through Rolfe's entire tenure. Fred Hutchinson, who still worked occasionally on the hill, took over in 1952. Hutchinson managed Detroit until 1954, when Bucky Harris returned for two pathetic seasons in 1955 and 1956. Through it all, we loved the fight, loved the game, and we always will.

"Dizzy" Trout
Career 1939–1957 Detroit 1939–1951

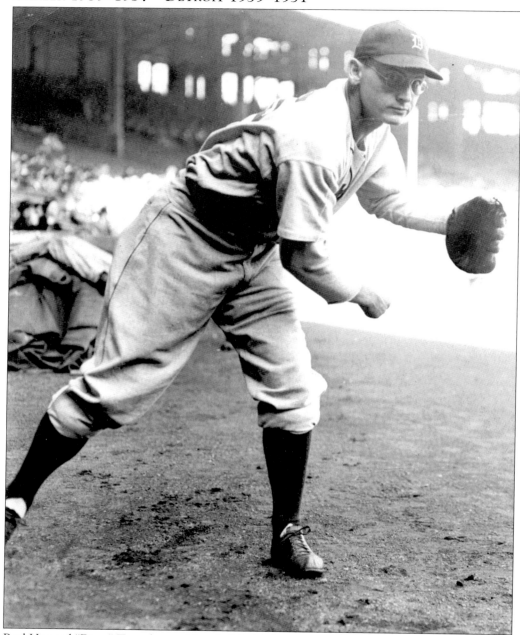

Paul Howard "Dizzy" Trout learned baseball in his home state of Indiana. He arrived a rookie in Detroit at the age of 24 in 1939 and almost immediately entered the starting rotation.

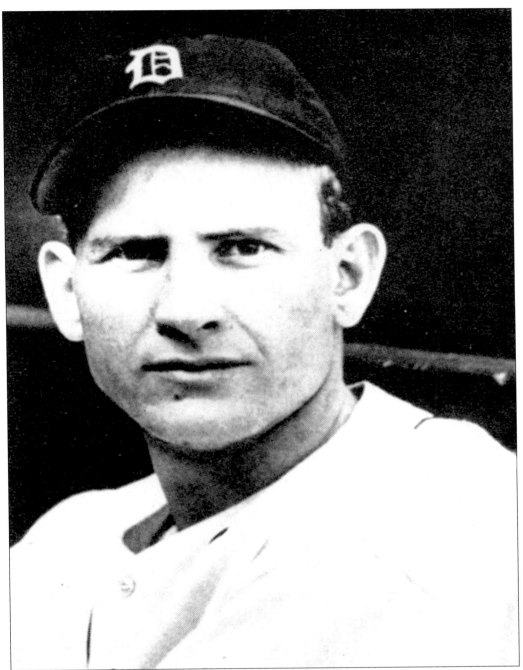

Outside of half a season in Boston, and a failed comeback with the Orioles in 1957, Trout was a Tiger. Of his 170 total wins, all but 9 were for Detroit. He won 20, topping the American League, in the mid-war season of 1943, then put up a 27-14 record in 1944, followed by 18 wins in the pennant-winning year of 1945. It was in 1945, during a September stretch, that Trout won four games in nine days to keep the team on track. He then threw a five-hitter at the Cubs in the World Series, winning a complete game 4-1

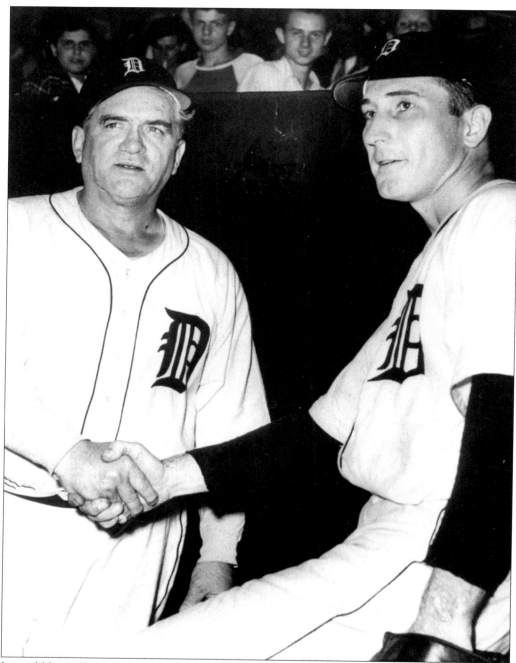

It would be a shame if Fred Hutchinson didn't like the city of Detroit, because he was with the Tigers for a very long time. His 95 wins over 11 years were enjoyable for the fans, but he was never a big part of a pennant win here. He tossed in one inning in the 1940 World Series and missed the entire 1945 season. In 1947, he won 18 games and in the next three seasons won 13, 15, and 17, respectively. He was more remembered as a manager. Above, he greets Steve O'Neill, left, at spring training in 1948.

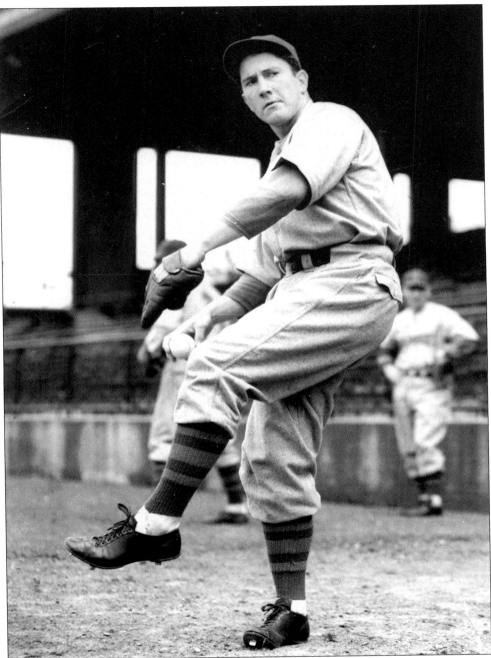

Photographed warming up before a game, Hutchinson was a hot-tempered leader but beloved by his charges. The Tigers admired the way he stuck up for them against opponents and umpires alike. Hutchinson ended his baseball career as manager of the Reds.

HAL NEWHOUSER
CAREER 1939–1955 DETROIT 1939–1953

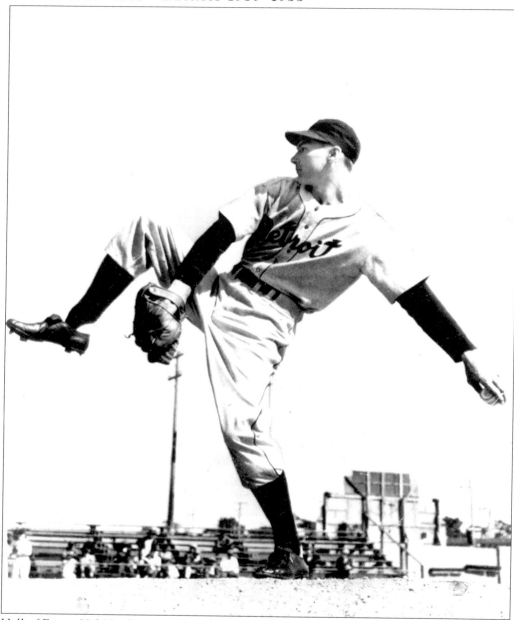

Hall of Famer Hal Newhouser was so dominant in 1944 and 1945 that he won Most Valuable Player Awards in both those years, the only pitcher ever to achieve the honor twice. His total numbers did not put him in the Hall, as his total games won were but 207. Instead, his five-year complete domination of the American League got Newhouser the votes. He won 29 games in 1944, 25 in 1945, 26 in 1946, 17 in 1947, and 21 in 1948. In the 1940s, if Newhouser won more than 20, he was leading the league.

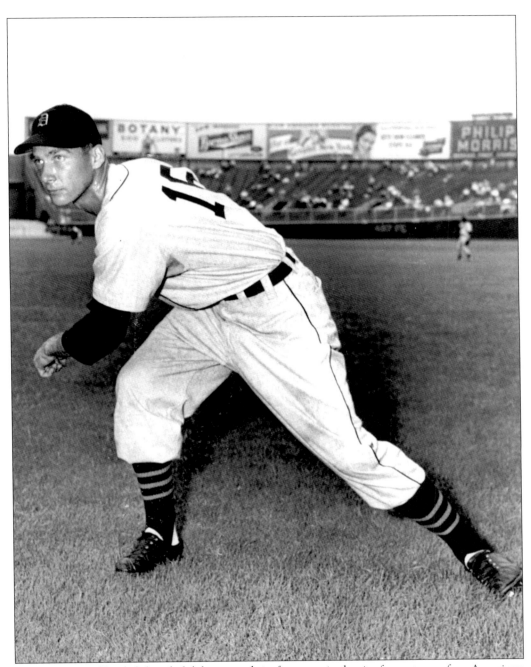

Newhouser used his left-handed delivery and six-foot-two-inch wiry frame to confuse American League hitters for 17 years. His lifetime ERA was 3.06, through the fat and lean years, a Tiger for all but 28 appearances of his 488 total. Newhouser's start with the Tigers was an unpleasant one. According to legend, within minutes of signing a contract with the Tigers for $400, Cleveland Indians's scout Cy Slapnicka showed up with an offer of a new car plus a $15,000 bonus. Slapnicka was too late and Newhouser $14,600 poorer. The pitcher must have gotten over it, as he collected paychecks from the Tigers for 15 years thereafter.

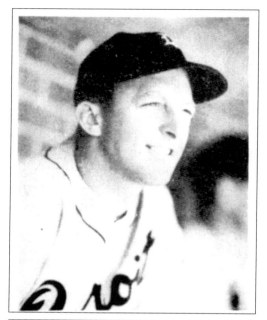

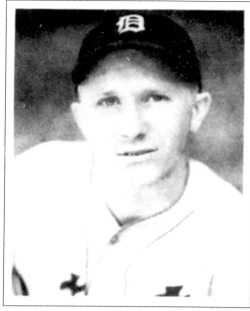

The bubble gum cards that Play Ball issued in 1939 and 1940 were among the least attractive ever collected. But, they were our iconographic connection to the players and to the Tigers. The 1939 cards appear on this page, with Bud Thomas, top left. Thomas pitched in three seasons here, 1939–1941, used almost entirely as relief, once winning games in seven straight appearances. Slick Coffman (top right) also worked from the bullpen, assisting in late innings from 1937 to 1939. When he came up to the Tigers as a rookie, he beat Lefty Grove in his first start 4-2. Jim Walkup (bottom left) was in town so briefly (seven games in 1939) that the fans don't even remember him.

Illustrated here are 1940 versions of the Play Ball cards. To the right is Cotton Pippen, who arrived a prospect with bright hopes, appeared in only seven games, and then disappeared. Lyn Nelson, whose card appears below, carried a longer major-league record, pitching for the Chicago Cubs and Philadelphia Athletics before arriving in Detroit in 1940, where he would end his career after six games with the Tigers.

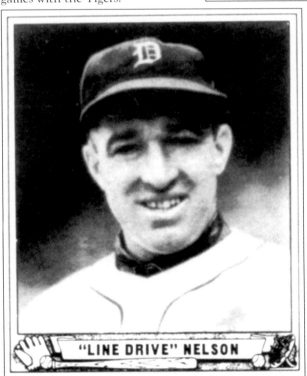

"COTTON" PIPPEN

"LINE DRIVE" NELSON

Johnny Gorsica
Career 1940–1947 all in Detroit

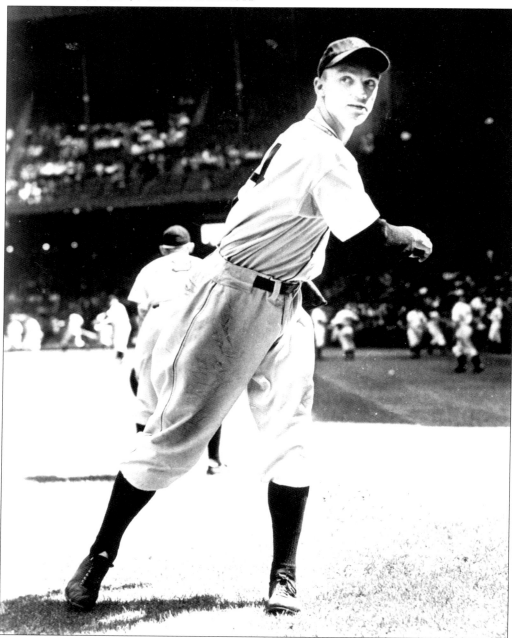

John Gorczyca (birth name) used his sinker ball both as a starter and a reliever for Detroit in seven seasons. His finest moments were in the 1945 World Series, when he relieved in games two and six, pitching 11 total innings while compiling an ERA of 0.79.

"STUBBY" OVERMIRE
CAREER 1943–1952 DETROIT 1943–1949

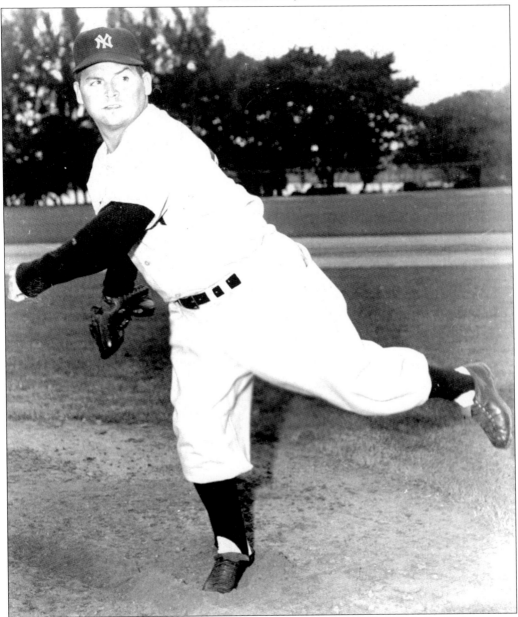

Stocky five-feet-seven-inch Frank Overmire's nickname was no surprise. And if he had one great season, it was in 1945. He went 9-9 with four saves that year and then in the World Series lost a heartbreaker to Claude Passeau of the Cubs 3-0.

VIRGIL TRUCKS

CAREER 1941–1958 DETROIT 1941–1952, 1956

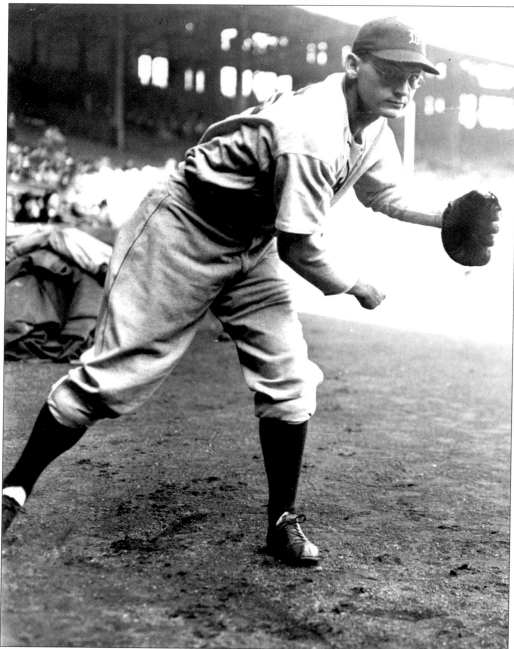

Sometimes we thought Virgil Trucks was a tractor trailer, as he was Detroit's workhorse on the mound for 11 straight years. He finished most of the games he started, and mostly due to his 10 productive seasons in Detroit, he ended his career with 177 victories.

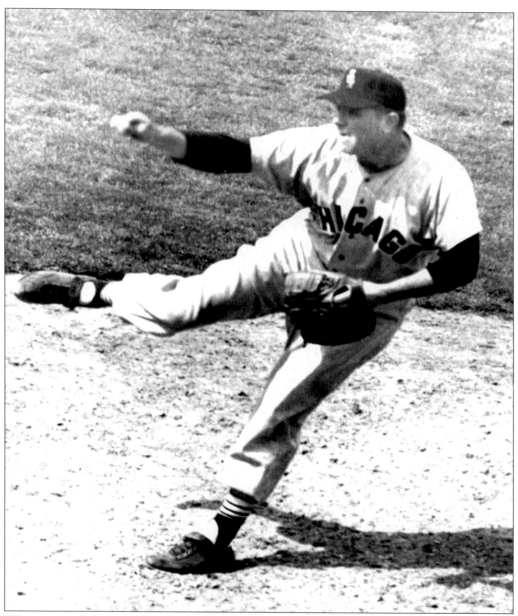

When he got hot, there was no one better to watch, and we knew it. In the memorable 1952 season, Trucks tossed two no-hitters—one against the Senators and one against the Yankees. When he came home after serving in World War II, it was near the close of the campaign in 1945. The Tigers were in the Series, and Trucks was right in the middle of it. He started games two and six and won his initial start versus the Cubs, throwing a seven-hitter in game two and earning a 3.38 ERA in the series. Here, Trucks wears the uniform of the White Sox, the team with which he finished his career in 1958.

ART HOUTTEMAN
CAREER 1945–1957 DETROIT 1945–1953

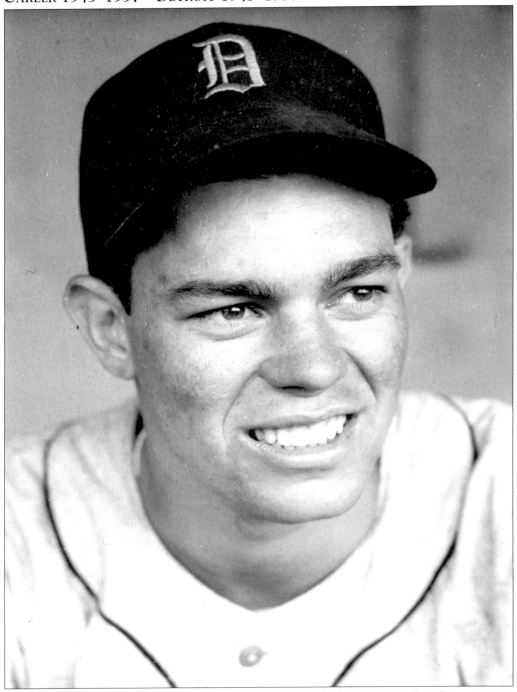

Art Houtteman was a native Detroiter, born in the city in the hot summer of 1927.

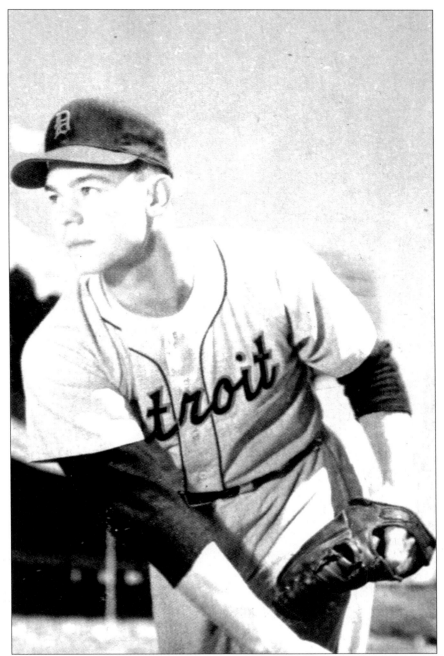

Houtteman pitched in neighborhood games as a kid, not three miles from Briggs Stadium. It was on these fields that Tiger scouts discovered him and signed him to a contract. He first worked out of the bullpen, but by 1949, he was starting games for the team. He used a curveball and a drop pitch to develop into a big-league competitor. In 1950, he won 19 games, which would be his highest figure. The following campaign was not nearly as beneficent, as Houtteman led the American League in games lost with 20, as he was suffering from the death of a child in an automobile accident. After being traded to Cleveland, he appeared in two games in the World Series.

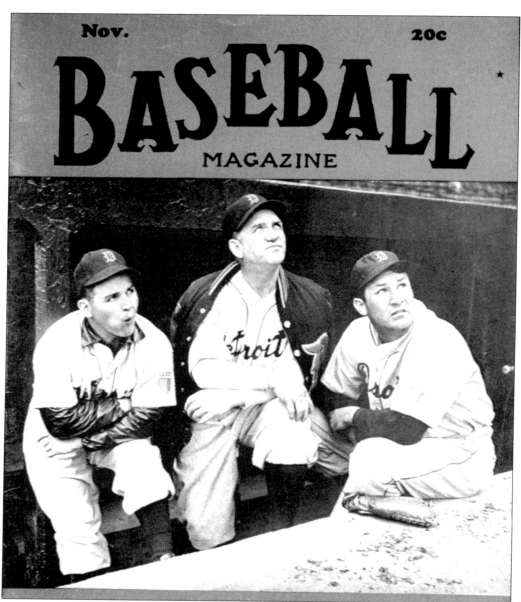

Nov. **20c**

BASEBALL
MAGAZINE

We could not wait for each month's issue of *Baseball Magazine*, because it contained more good writing and analysis of the game than any other publication. The Steve O'Neill era saw these two Tiger covers, each posed on the dugout steps. Inside there were articles on the Tigers with information that would not be found in the daily newspapers. The magazine also had a corps of photographers who provided great images for the readers every four weeks. The cover above was issued in 1944, with O'Neill watching a pop-up during batting practice, with Rudy York flanking him on the right and Billy Rogell on the left.

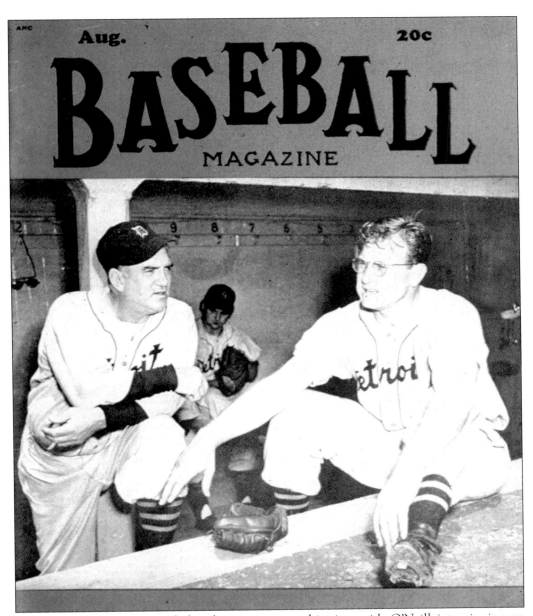

BASEBALL
MAGAZINE

In August 1948, we received the above cover art, this time with O'Neill interviewing an exhausted-looking Dizzy Trout. Tiger fans loved to keep mementos of their heroes. Over the years, we collected not only magazines like these but pennants, yearbooks, scorecards, newspaper clippings, photographs, ballpark giveaways, along with the foul balls for those fortunate enough to grab one during games or batting practice.

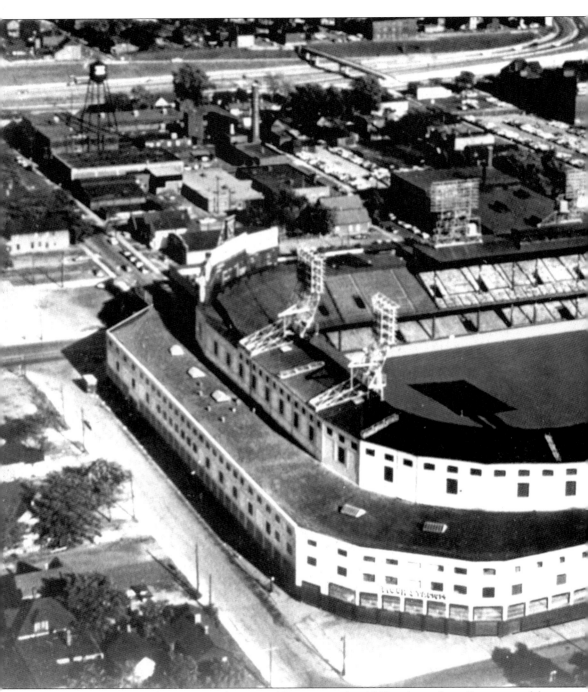

If you were up in the air over the city of Detroit in the 1940s, this is how Briggs—and later Tiger—Stadium appeared. The old sheet-metal bandbox was the Tigers' home from 1912 until 2000. With downtown, the river, and the city of Windsor, Ontario, in the background, the ballpark was near the center of activity in the city. Called Navin Field after the Tigers' owner, the space was renamed Briggs Stadium in 1937 and remained so until 1960. Thereafter, the structure

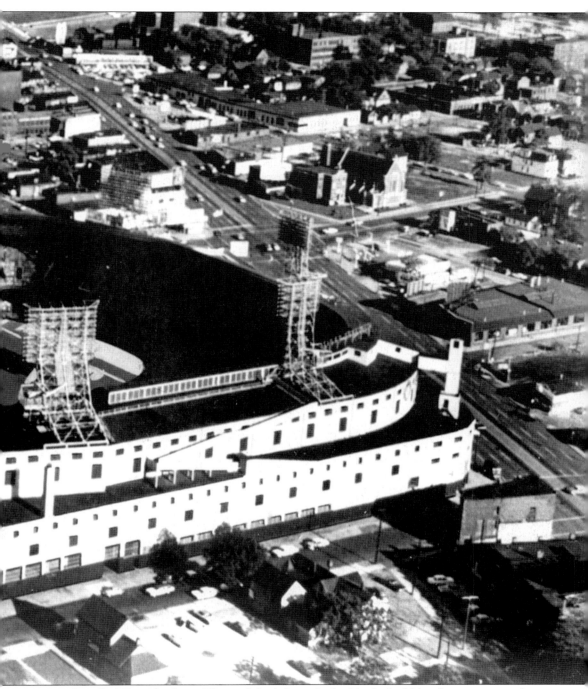

was simply called Tiger Stadium. The park had the only double-decked bleacher section in the major leagues. It was the last 20th-century ballpark to be outfitted with lights, which happened in 1948. It is sad to think we can no longer see our boys perform in the place where baseball meant so much to Detroiters. Thankfully, these images help keep the memories fresh.

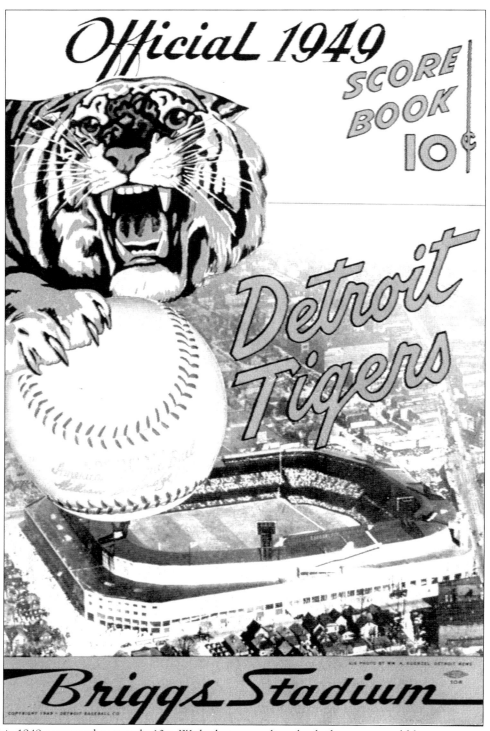

This 1949 scorecard cost only 10¢. With that same dime back then, you could buy two cups of coffee, two newspapers, or 10 packs of baseball cards.

TED GRAY

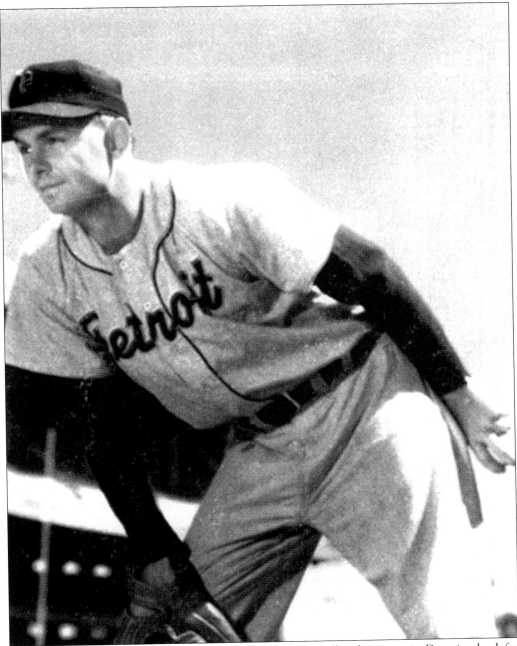

In 1949, Ted Gray was 10-10 for the Tigers. Another sandlot discovery in Detroit, the lefty pitched for eight major-league seasons in his hometown. Gray was mostly a starter, winning 58 games for the Tigers. He finished four years with wins in double figures, his highest being the 12-victory total in 1952.

Hank Borowy

Career 1942–1951 Detroit 1950–1951

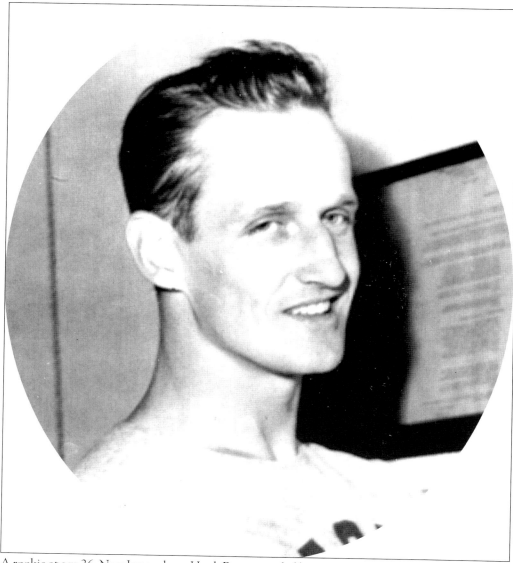

A rookie at age 26, New Jersey–born Hank Borowy ended his career in Detroit, where he won three games for the Tigers over two struggling seasons. Borowy had made his name with the Yankees and then the Chicago Cubs. He was traded mid-season of 1945, his only year in pitching's upper echelons, when he notched 21 victories split between the American and National Leagues.

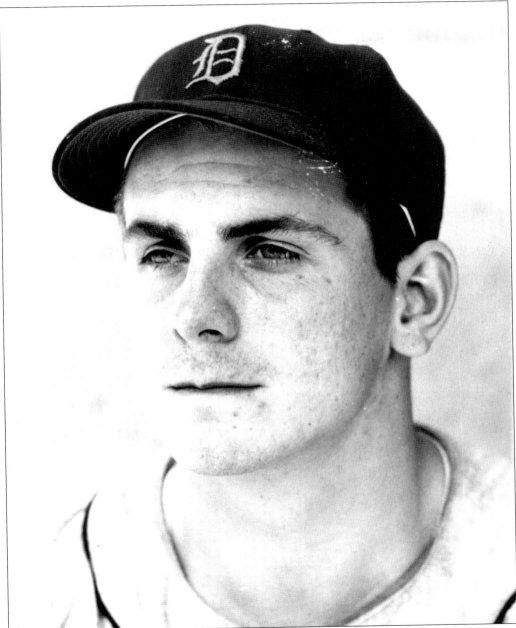

Ray Herbert did not last long in Detroit, though his career began here in 1950. He was a relief artist, and by the time he left town after the 1954 season, he had appeared in 85 games over two seasons. He reached his peak after being traded to the White Sox, where he was 20-9 in 1962, and then led the league in shutouts with seven in 1963. Herbert pitched 12 of his 14 major-league years in the American League.

NED GARVER
CAREER 1948–1961 DETROIT 1952–1956

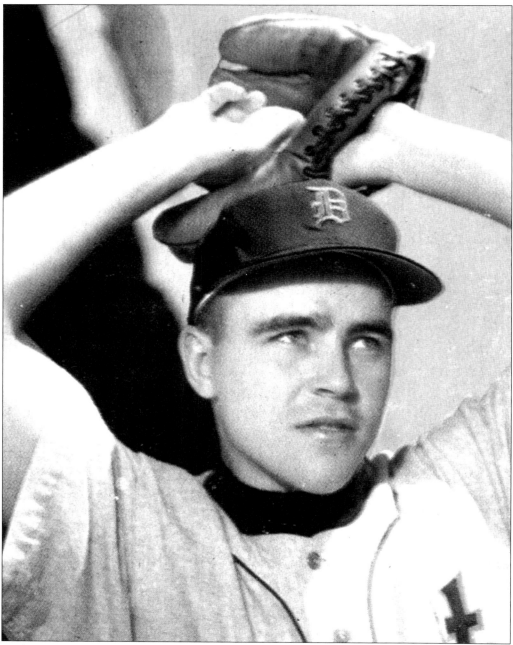

Ned Garver appeared with the Browns, Tigers, Athletics, and Angels throughout his 14-year career. He had been a 20-game winner with the St. Louis Browns before coming to Detroit, where his 14-win best year was 1954. After leaving the Tigers at the close of the 1956 season, he pitched four years in Kansas City, followed by his last with the Los Angeles Angels.

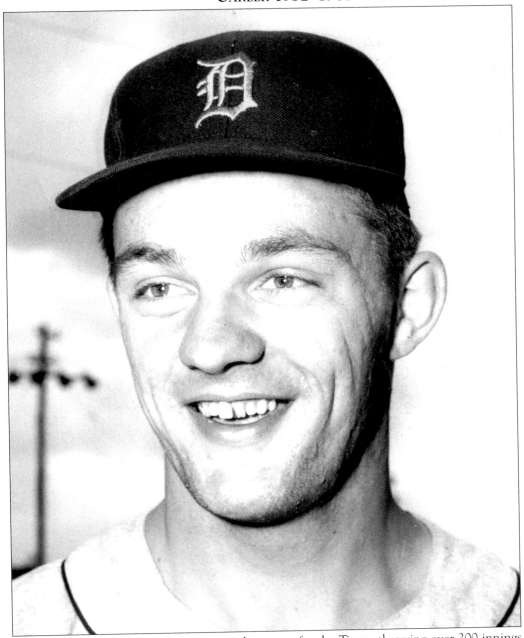

From 1953 to 1958, Billy Hoeft was a regular starter for the Tigers, throwing over 200 innings in three of those years. He finished 16-7 in 1955 and 20-14 in 1956, his most productive years. In the latter half of his career, he switched to the bullpen, packed his bags, and was moved to six different teams before retiring, including the Red Sox, the Orioles, the Giants, the Braves, and the Cubs.

SAUL ROGOVIN

CAREER 1949–1957 DETROIT 1949–1951

Saul Rogovin began an eight-year career in Detroit, mostly hiding in the bullpen, winning three games over three seasons. The team wished they had him back, since in 1952–1953, he hit his best stretch, winning 26 games for the White Sox. In 1952, he led the American League with an ERA of 2.78.

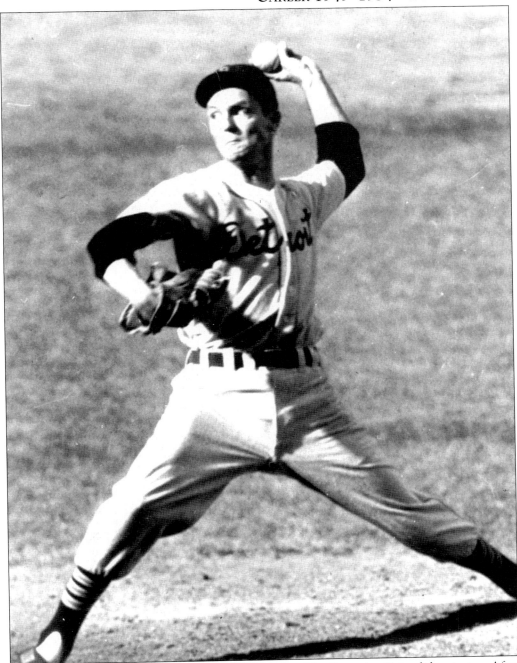

Bob Cain won 11 games for the Tigers in 1951, but like Rogovin, Cain did not stay. After departing, he pitched for the Brownies and Chisox. Used primarily as a starter, Cain suffered from control problems, often walking more batters than he struck out.

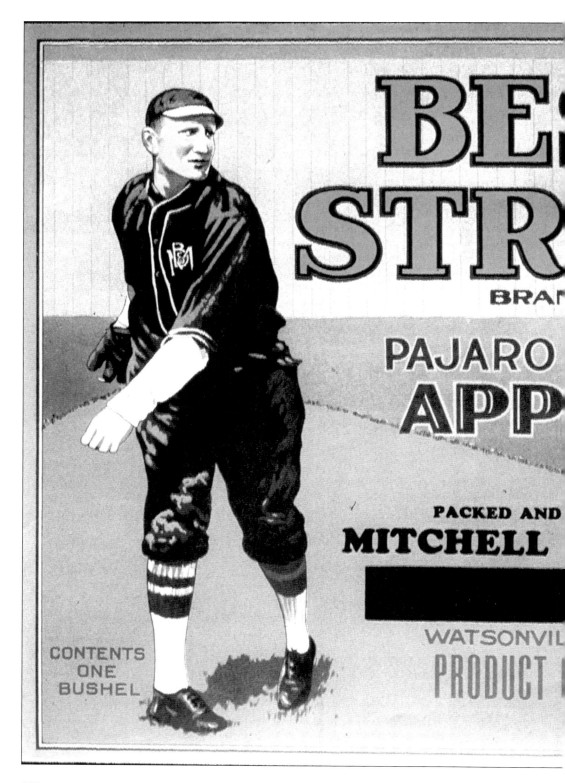

ST
KE

ALLEY
ES

PED BY

DESKO

CAL.

U. S. A.

We fans bought many products that used baseball and the Tigers to promote themselves. The players' faces were on milk cartons, and their baseball cards were in packages of Glendale hot dogs. We saved all the cards, pictures, newspaper clippings, and giveaways and put them in scrapbooks. Once in a while, we would get a shipment of fruit from California, and one year a crate came with this wonderful label.

HAL WHITE
CAREER 1941–1954 DETROIT 1941–1952

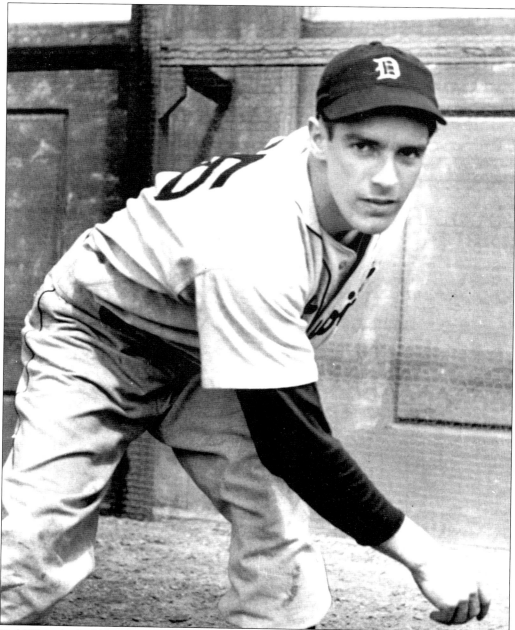

Hal White looked like the real deal in his rookie year of 1942, posting a won-loss record of 12-12. The sophomore jinx hit him in 1943, and then he was lost to the service for two seasons. The war did something to him; he was never the same after returning, and he became a middle-inning relief man and spot starter.

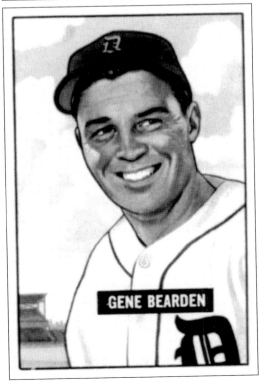

EARL JOHNSON

White's 1951 baseball card is on this page in the lower left. On the top right is the bubble gum card of Earl Johnson. Fans do not even remember him in a Tigers uniform. It turns out he pitched six games for Detroit in 1951 and then retired. On the lower right is Gene Bearden's card. Bearden was a tall lefty who pitched a total of 37 games for Detroit and then moved on to the Browns.

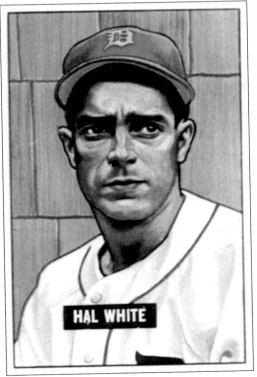

HAL WHITE

GENE BEARDEN

BILL WIGHT
CAREER 1946–1958 DETROIT 1952–1953

Left-hander Bill Wight threw in eight different major-league cities over 12 seasons. He had blossomed into a reliable starting pitcher in Chicago but soon developed arm trouble and could not stick with any club. Wight appeared in 36 games for the Tigers, about half in a starting role, and ended his playing days with a 77-99 record.

DAVE MADISON

pitcher **DETROIT TIGERS**

Dave Madison's 1953 Topps baseball card is included here to illustrate that year's cartophilic obsession for most kids in Detroit. He was most famous for being part of the trade bringing Vic Wertz to the Tigers.

FRANK LARY
CAREER 1954–1965 DETROIT 1954–1963

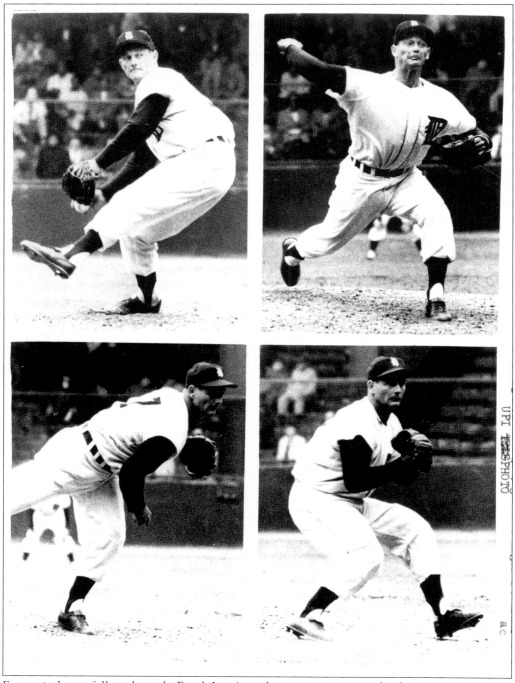

From windup to follow-through, Frank Lary's pitching motion was textbook.

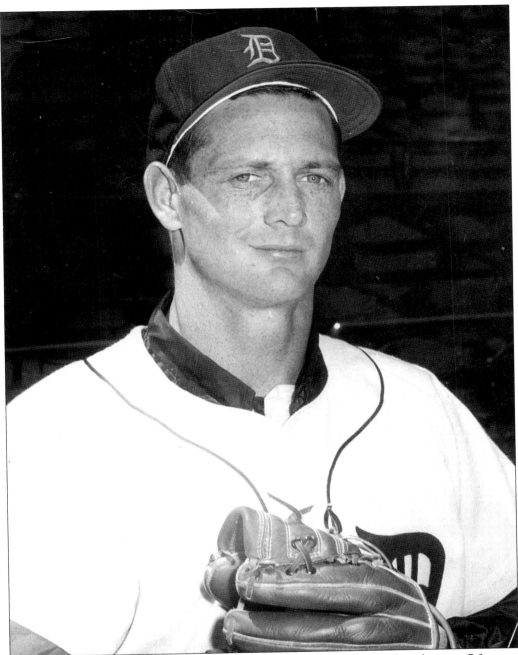

We loved Frank Lary, the Yankee killer! Lary had an amazing fastball and used it to go 7-0 versus the Bronx Bombers in 1956, the same year he would lead the American League in wins with 21 and in innings pitched with 294. He would remain in the starting rotation through 1961, a year in which he turned in a brilliant 23-9 performance, as well as throwing 22 complete games. Many thought he threw out his arm that September, because by 1962, he was struggling in 14 games to post a 2-6 record. Lary lasted until 1965, having been traded four times after leaving Detroit.

JIM BUNNING
CAREER 1955–1971 DETROIT 1955–1963

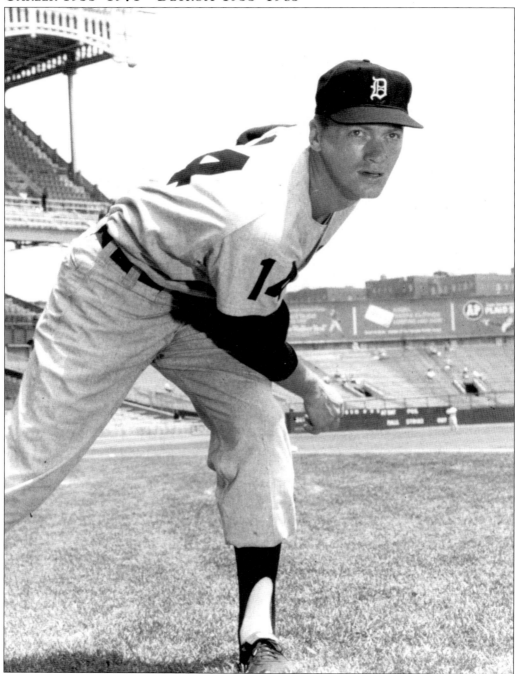

Jim Bunning split his major-league career between the leagues. He threw for his first eight years as a Tiger and his final eight years as a Philadelphia Phillie.

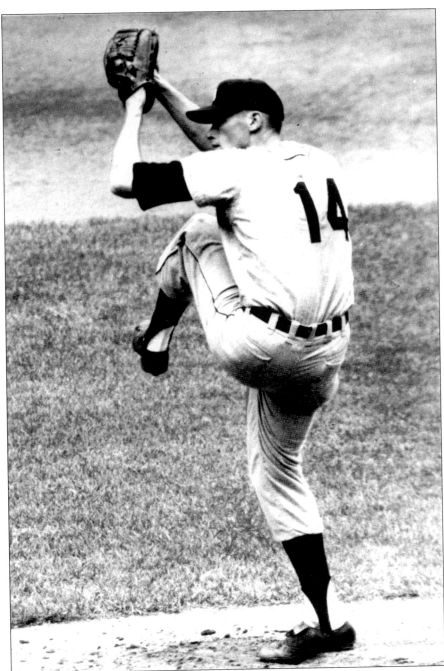

Where would Jim Bunning's career have been without Detroit? And where would Detroit have been without him? Lower in the standings, no doubt. Bunning came up a rookie in 1955, playing in 15 games, and as a sophomore again appeared 15 times but with improved statistics. By the close of the 1956 season, he had tested himself against the best hitters in the American League. But he even surprised himself in 1957 when he won 20 games, a total that led the league and that he never again equaled, even after he jumped to the National League.

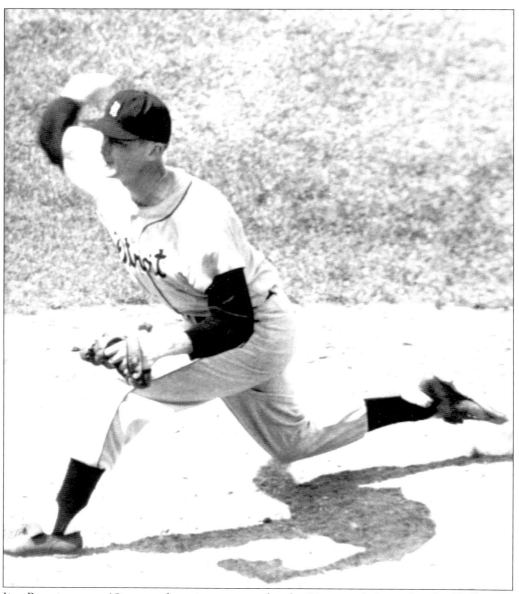

Jim Bunning won 19 games four times—once for the Tigers and thrice for the Phillies. In both 1959 and 1960, he led the league in strikeouts. His real claims to fame, however, are the statistical totals he compiled in *both* the American and National Leagues.

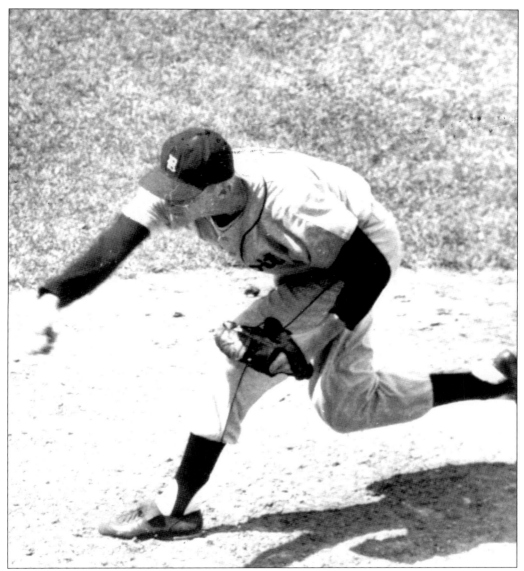

No one since Cy Young had won over 100 and struck out over 1,000 in both major leagues until Jim Bunning. He was assisted by his bizarre delivery, involving a sidearm release, while he seemed to fall forward off the mound. He was particularly adept at fooling hitters on two different occasions. He threw a no-hitter for Detroit in 1958 and then, six years later, delivered a perfect game for the Phillies.

PAUL FOYTACK

CAREER 1953–1964 DETROIT 1953–1962

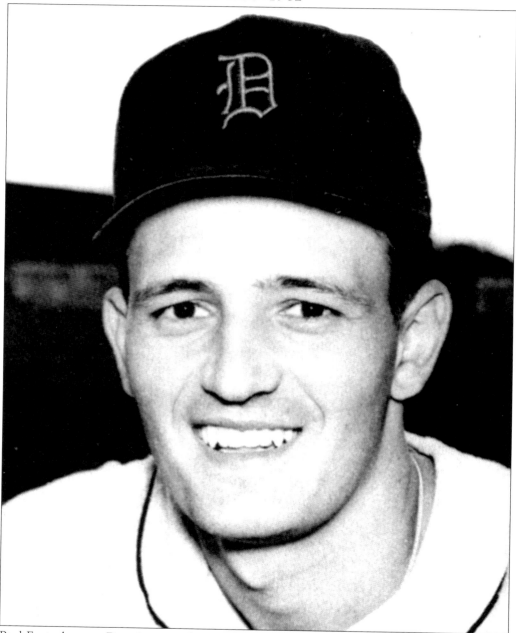

Paul Foytack was a Detroit starter from 1956 to 1962. During his stay in the rotation, he won 15 games twice, in 1956 and 1958. He finished his 11-year career in Los Angeles playing for the Angels, but 81 of his 86 total victories were produced as a Tiger.

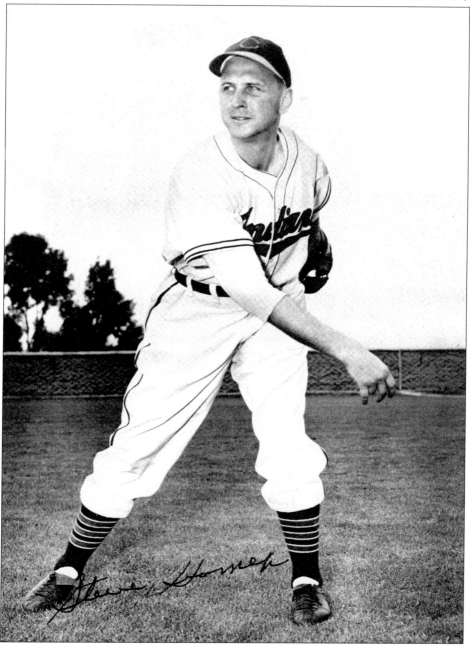

This pitcher grew up in Hamtramck, not far from the center of all baseball activity, Tiger Stadium. Gromek, shown here in an Indians uniform, toiled away for Cleveland for 13 seasons before coming to the Tigers. In his first full year here, he went 18-16 to become the team's number one starter by the end of August.

HANK AGUIRRE
CAREER 1955–1970 DETROIT 1958–1967

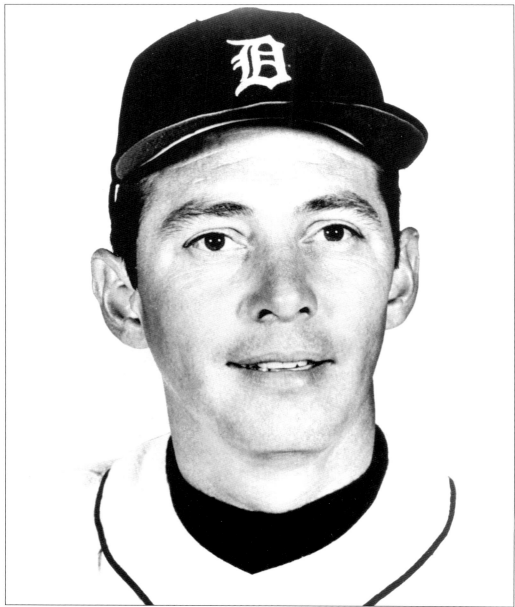

Cleveland and Detroit traded so often in the 1950s that a special bus seemed to run continuously between the two cities. That is how screwball artist Hank Aguirre got to the Motor City and then stayed for 10 seasons. He was an all-star for Detroit in 1962, when he ended the season at a sensational 16-2. He won 14 for the Tigers twice after that. No doubt about it, the team got Aguirre's best years.

DON MOSSI

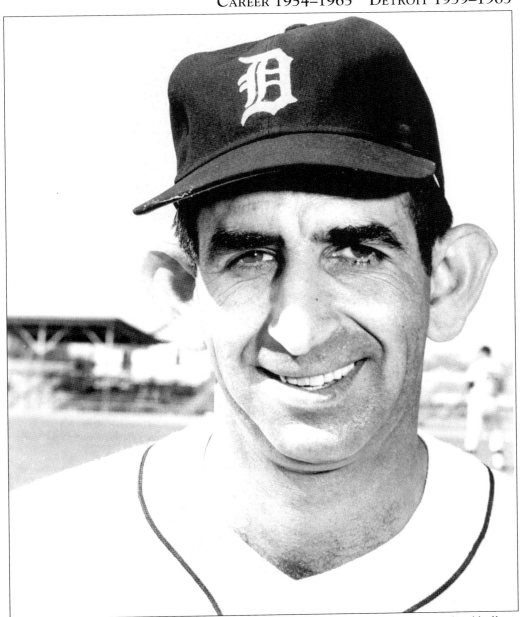

Don Mossi, known as the "Sphinx," was working quite successfully out of the Cleveland bullpen for his first three seasons. In 1957, Indians manager Kerby Farrell trusted him for a starting role, and Mossi was fairly successful. In 1958, new Indians manager Bobby Bragan sent him back to the bullpen. But the brass in Detroit liked Mossi's control and potential as a starter. After signing with the Tigers, he won 17, 9, 15, and 11 in his first four years.

DICK DONOVAN
CAREER 1950–1965 DETROIT 1954

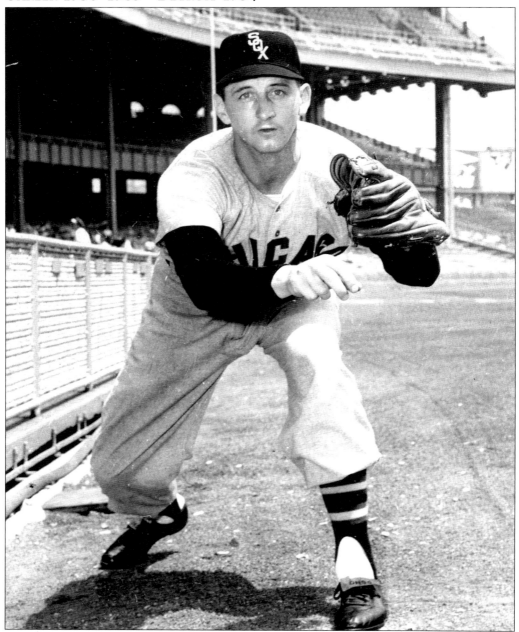

For us in Detroit, Dick Donovan is just a bad memory. He could not do much in three seasons in Boston, nor in one here. But after the White Sox grabbed him and taught him the slider, he suddenly was a useful major leaguer, winning 15 games in 1955. He won 12 in 1956, 16 in 1957, and 15 in 1958, all of which just made us in Detroit mad. Perhaps the photograph of Donovan above in a White Sox uniform makes more sense now.

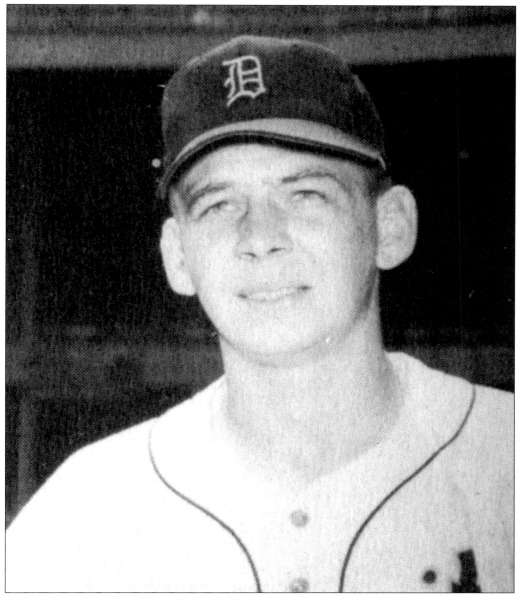

Al Aber was known as "Lefty," and he used that left arm to work in relief for the Tigers for four successive seasons. He saved 13 games over those years as a bullpen mainstay, with an ERA just good enough to keep him in the majors.

Bibliography

The Baseball Encyclopedia. New York: Macmillan, 1976.

Cohen, Richard S., David S. Neft, Roland T. Johnson, and Jordan A. Deutsch. *The World Series.* New York: Dial Press, 1976.

Lieb, Frederick. *The Detroit Tigers.* New York: Putnam, 1946.

Lowry, Phil. *Green Cathedrals.* Cleveland, OH: SABR, 1986.

Okkonen, Marc. *Baseball Uniforms of the 20th Century.* New York: Sterling, 1991.

Palmer, Peter, John Thorn, and Michael Gershman, eds. *Total Baseball.* New York: Total Sports, 1999.

Reach Baseball Guides. Philadelphia: A. J. Reach and Company, 1882–1920.

Riley, James. *The Biographical Encyclopedia of the Negro Leagues.* New York: Carroll and Graf, 1994.

Schatzkin, Mike, ed. *The Ballplayers.* New York: Arbor House, 1990.

Spalding Baseball Guides. Springfield, MA: Spalding, 1882–1935.

All photographs courtesy of Transcendental Graphics / www.theruckerarchive.com.

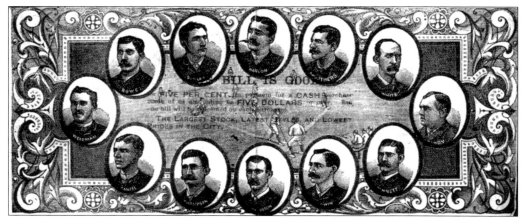

When the team was winning almost every day back in 1887, local merchants wanted to jump on the bandwagon. This storekeeper offered an advertising flyer in the form of a dollar bill, with portraits of all the players. The promotion must have worked since they did not stay in the stores very long.